L
AND

Mr. Limbaugh

Logic
AND
Mr. Limbaugh

*A Dittohead's Guide to
Fallacious Reasoning*

Ray Perkins, Jr.

OPEN ✹ COURT
Chicago and La Salle, Illinois

OPEN COURT and the above logo are registered in the U.S. Patent and Trademark Office.

© 1995 by Open Court Publishing Company

First printing 1995

Printed and bound in the United States of America.

Library of Congress Cataloging-in-Publication Data

Perkins, Ray, Jr.
 Logic and Mr. Limbaugh : a dittohead's guide to fallacious
reasoning / Ray Perkins, Jr.
 p. cm.
 Includes index.
 ISBN 0-8126-9294-2 (pbk.)
 1. Fallacies (Logic)—Case studies. 2. Logic—Case studies.
3. Limbaugh, Rush H. I. Title.
BC175.P47 1995
165' .092—dc20 95-3931
 CIP

For Karen

Contents

4 / Rush and Multiculturalism

5 / Rush and Animal Rights

6 / Rush on Sex Education

7 / Rush on Crime and Punishment

Acknowledgments

The completion of this book gives me welcome opportunity to thank those who have assisted in matters great and small.

Thanks to my students and colleagues at Plymouth State College: Tracy Blake, Amy Casey, Paul Fedorchak, Juanita Field, Douglas Fife, David Haight, Phil Hart, Constance Leibowitz, Deb Naro, Robert O'Neill, John Strang, Susan Walsh, Joe Whippen; and especially to Herb Otto who read large portions of the manuscript and made many valuable suggestions regarding matters of logic.

To the folks at Open Court for their guidance and unflagging assistance: Jaci Hydock, Jeanne Kerl, Edward Roberts; and to my editor, David Ramsay Steele, whose astute criticisms made possible (and necessary) numerous improvements.

To my friends and associates who provided ideas, information and encouragement: Sandra Bargainnier, Jack M. Clontz, Tom Field, Steve Manning, Jim Meares, William Murphy, Dick Ober, John O'Connor, James W. Oliver, Arthur Perkins, Bob Puckhaber, Andrew Rehm, Linda Rehm, Shelley Ross, and Foster Tait.

To my cartoonist, Mike Marland, whose considerable talents have lightened the burdens of logic.

A special thanks to my family: my mother, Elizabeth S. Perkins; my wife Karen, and my daughters Kendall and Candice, for their constant support and generous quantities of tolerance.

And, of course, to Rush Limbaugh, without whom this book would not have been possible.

Ray Perkins, Jr.
Webster, NH
February 27th, 1995

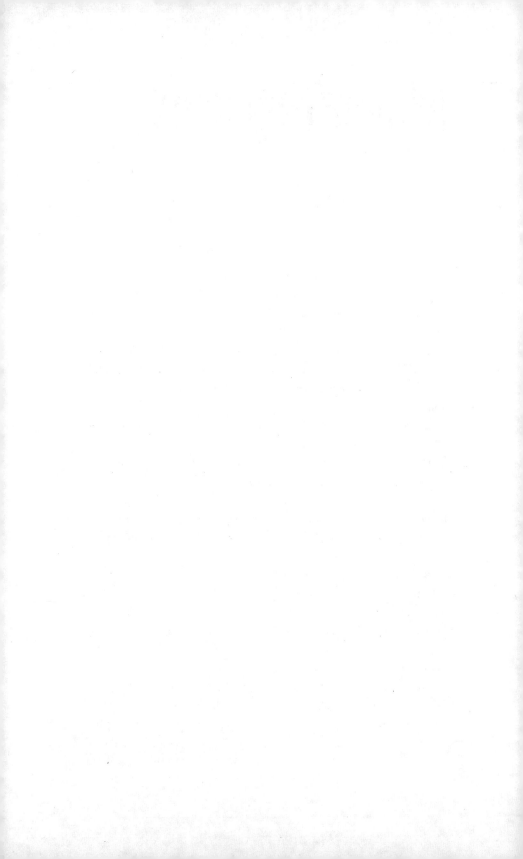

Introduction

WHO IS RUSH LIMBAUGH?

Rush Limbaugh, as nearly everybody now knows, is a conservative radio talk show host who rocketed to fame in the late 1980s and who is today one of our country's most celebrated and controversial personalities. Rush's daily three-hour radio program is heard by some 20 million listeners each week over more than 600 stations nationwide. He also has a very popular T.V. program aired nightly and viewed by millions.

Not only has Mr. Limbaugh become famous, he is also an object of attention of the most important people in the land. President Bush made a guest appearance on his radio show in an attempt to win the 1992 election; Justice Clarence Thomas presided over a private marriage service for Rush and his wife Marta at Thomas's house in 1994; and President Clinton has publicly criticized Limbaugh and his antiliberal talk show on more than one occasion. Rush's two books —*The Way Things Ought To Be* (1992) and *See, I Told You So* (1993)— have sold over seven million copies. His right-wing politics and his bombastic egotism ("with talent on loan from God"; "with half my brain tied behind my back just to make it fair") are well-known, if not always admired, by conservatives and liberals alike.

He is, in the eyes of many, a very funny guy, and even those who find his brand of wit irksome will usually admit his talent as a first-rate entertainer. Even those who find him thoroughly unpalatable will concede that he does stimulate controversy and thought on things

political. Indeed, Rush has probably done as much to turn Americans on to politics as all the civics courses in all the public schools in the land. ('That's not saying a whole lot,' I hear some dittoheads interject. They may have a point. A 'dittohead', for those of you who don't know your Rushian, is a Rush Limbaugh fan.) And that, even from the perspective of Rush's liberal critics, can hardly be a bad thing.

POLITICALLY—AND LOGICALLY—INCORRECT

Rush Limbaugh prides himself on his political incorrectness, and he is admired by many for it. As William F. Buckley, Jr. put it: "Whenever I hear Rush Limbaugh I marvel . . . that his war on Political Correctness is tolerated. . . . It's like a jolt of champagne for most of us, reorienting the day, reassuring us that social disorders haven't disturbed the essential movements of the planet."

Now there is not, of course, anything necessarily wrong with being politically incorrect. But *logical* incorrectness is another matter. To be *logically incorrect* is to be guilty of bad reasoning, or FALLA-CIOUS reasoning, as I prefer to say. Much of Rush Limbaugh's reasoning is logically incorrect or FALLACIOUS. Yet, much of his reasoning is persuasive to many people. And therein lies the rub. We are, all of us, in our discourse with our fellows, obliged to avoid—or at least try to avoid—FALLACIOUS reasoning. FALLACIOUS reasoning is a kind of counterfeit, and like bad money, it should be identified and rejected whenever encountered.

Let me try to say very briefly what I mean, and what I don't mean, when I say that much of Rush's reasoning is FALLACIOUS. I don't mean (at least not primarily) that Rush doesn't have his facts straight (although sometimes he doesn't); nor do I mean that Rush's political opinions or beliefs are mistaken (though, no doubt, they sometimes are). What I do mean is that his opinions and beliefs are often *poorly argued for;* that they are often supported by reasons that are either weak or irrelevant to the truth of those opinions and beliefs about which he's trying to persuade us. This, as I say, is not a matter of not having correct facts and opinions; it's a matter of not having correct *logic.*

This point cannot be stressed too heavily. The point of reasoning is to provide good grounds—good reasons—for believing that something (logicians call it the CONCLUSION) is so. If our reasoning is FALLACIOUS, we commit the error of believing something without proper justification, and, as a result, we run an increased risk that what we believe to be true may actually be false.

Whether Rush knowingly advances fallacious ARGUMENTS in order to persuade his audience is something we needn't speculate about. He *says* that he is sincere and that he wants to be taken seriously. As Rush himself puts it:

> Remember this . . . : My success is determined by how many listeners I have. You might be wondering if this means that I don't care about my beliefs. . . . To the contrary, they are my heart and soul . . . and I never betray them or misrepresent them in the pursuit of audience. . . . I present my views with the utmost responsibility and sincerity.
>
> (*The Way Things Ought To Be*, p. 22)

We need not doubt Rush's sincerity. Unfortunately, sincerity is no guarantee against FALLACY. In saying this we do not mean to pick on Rush as though he were somehow unique in logical sin. The fact is, as we shall see, that many of us—liberal and conservative alike—fall victim to the lure of FALLACIOUS rhetoric. But while not alone in the propensity to logical error, Rush Limbaugh does stand out as one of the most popular and potentially influential people of our day. It's obviously desirable that such a voice be as far from FALLACY as possible; and where FALLACY does raise its duplicitous voice, we, as audience, need to be able to identify it and resist the temptation to persuasion. It's in this spirit of improving the quality of our national dialogue that I offer this book on logic and Mr. Limbaugh. If the lessons herein are well learned, the reader will be better equipped to spot the logical mistakes committed by all kinds of personalities across the political spectrum. And that's a goal of which I'm sure Rush would approve.

THE PLAN

Our task is one that will require a little *preliminary discussion* (Chapters 1 and 2) on the nature of reasoning in order to explain some basic ideas in logic, for those who would like a bit of brushing up on fundamentals. It will also involve a generous quantity of *application* (Chapters 3–9) as we turn our logical lessons to Rush's writings and examine several dozen examples of Limbaugh's logical legerdemain (those would be FALLACIES, for you dittoheads who may have forgotten your French).

Of course, for the more advanced readers—as well as for those dittoheads who simply can't wait to get to Rush's stuff— I hereby give my permission to go to the chapters on Rush's FALLACIES (Chapters 3–9) straight away. In fact, all my readers will be pleased to know that while the first two chapters on logic and FALLACY will be helpful in providing a solid basis for understanding the discussions of Rush's FALLACIES, (not to mention their, ahem, intrinsic interest), they are not essential for understanding and appreciating those discussions. Indeed, each of Rush's ARGUMENTS from the many examples given, is discussed and analyzed by itself, and can be read and understood separately from the others. In each of Rush's ARGUMENTS, I make the attempt to start the discussion more or less afresh, pointing out for the reader where the relevant points were discussed and summarizing those points as they apply to the ARGUMENTS under consideration. No doubt, this means a certain amount of repetition concerning the logical lessons involved, but, to paraphrase a famous conservative thinker (whose arguments were always watertight and worth their weightiness in gold): 'Repetition in the interest of clarity is no vice.'

OTHER BOOKS ON LOGIC

You can read *Logic and Mr. Limbaugh* purely for entertainment, or just to sharpen up the logical awareness you already possess. But possibly you may enjoy this book so much that you want to learn a bit more about logic

There are many good books on logic for beginners. I particularly recommend the following:

Kahane, Howard. *Logic and Contemporary Rhetoric.* 7th edition; Wadsworth, 1995.

This book is especially good on FALLACIES and their application to the news media and current social/political events

Copi, Irving and Carl Cohen. *Introduction to Logic.* 9th edition; Macmillan, 1994

An old standby among college logic instructors. It is very comprehensive and covers traditional as well as symbolic logic. It includes a generous discussion of INDUCTIVE reasoning as well as an interesting chapter on legal reasoning.

Fogelin, Robert and Walter Sinnott-Armstrong. *Understanding Arguments.* 4th edition; Harcourt Brace Jovanovich, 1991.

This is a very good and comprehensive account of ARGUMENT. It is especially good on the nature of language, and it has several very useful chapters on the application of ARGUMENT in areas of law, morals, science, and philosophy.

Seech, Zachary. *Open Minds and Everyday Reasoning.* Wadsworth, 1993.

A very readable and concise account of everyday reasoning

Basic Logic

Keeping Your Thinking Straight

1

WHAT IS LOGIC?

Logic is serious business. (Indeed, it is my business; I teach logic and critical thinking for a living at a state university.) It is the science of correct reasoning, whether conservative reasoning or liberal, whether the reasoning be in politics or in physics. As the ancient Greek philosopher Aristotle put it, logic is not so much itself a science in the ordinary sense as it is a prerequisite for *any* science. And in that sense we might say that logic is the science of *all* sciences and, indeed, of any area of inquiry. Since Aristotle's day (around 350 B.C.) logic has been part of the standard philosophy curriculum and, not surprisingly, has usually been taught by philosophy professors. Sometimes more specialized logic courses, for example, those concerned with the logic of computers or those concerned with the logic of mathematical systems, are taught by educators in computer science or mathematics.

1

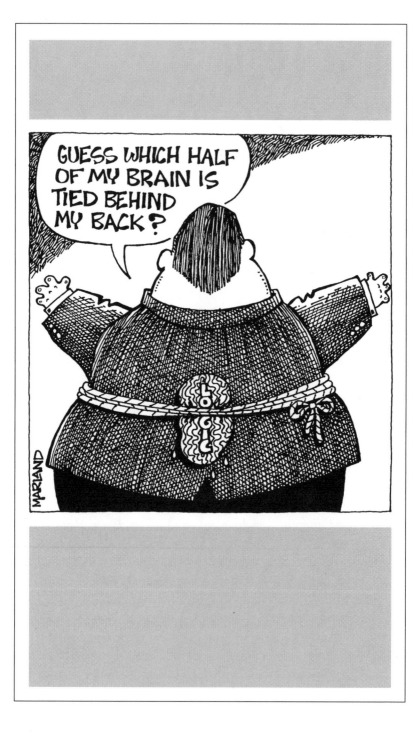

We've already said that logical correctness of reasoning is at the very heart of what logic is about. Here's an example of such reasoning (with a slight variation on Aristotle's famous example; I don't think Rush would mind):

(1) All men are mortal
 Rush Limbaugh is a man.
 Therefore, Rush Limbaugh is mortal.

In (1), we are providing reasons (the logicians call them 'PREMISSES' —I realize there's another way to spell it, but I like this one) for the CONCLUSION that Rush is mortal. The whole point of such reasoning, from the practical point of view, is to give us good reason for thinking that the conclusion is true. And, as any dittohead can plainly see, these two PREMISSES really are very compelling reasons for believing that Rush is mortal. In fact, these PREMISSES make it *absolutely certain* that Rush is mortal.

This bit of reasoning, by the way, is called an 'ARGUMENT', and it is a central idea in logic. (I know it has nothing to do with a heated disagreement, but it's still called an ARGUMENT.)

A logician would express the certainty of the above ARGUMENT about Rush's mortality by saying that if the PREMISSES are true, the CONCLUSION *must* (no ands, ifs, buts, or maybes) be true too. Another way to say it is that the PREMISSES provide *conclusive proof* for the CONCLUSION. When our reasoning provides conclusive proof for our CONCLUSIONS, it is logically correct, or, as the logicians prefer to say, VALID.

So why be concerned about logical correctness or VALIDITY? Let's remember that the whole point of reasoning (or making an ARGUMENT) is to prove the CONCLUSION. If our reasoning is not logically correct, that means that we haven't yet proven the CONCLUSION. And if we accept the CONCLUSION without proof, obviously we run the risk that we are accepting something that may not be true.

Now this matter of avoiding logical incorrectness is not quite as simple as following common sense. Sometimes our 'common sense' can lead us astray. (Sometimes the correct answer is 'counterintuitive' as the philosophers might say.) The following ARGUMENT is logically correct:

(2) Some dittoheads are gun owners.
 Therefore, some gun owners are dittoheads.

But consider the following which only *looks* correct:

(3) Some dittoheads are not gun owners.
 Therefore, some gun owners are not dittoheads.

ARGUMENT (3) is logically *incorrect*. Its PREMISS does not con-
clusively prove its CONCLUSION. 'But,' I hear dittoheads (and non-
dittoheads) loudly protesting, 'the CONCLUSION is TRUE.' Yes, the
CONCLUSION is true. And so is the PREMISS. But the truth of the CON-
CLUSION does not follow from the truth of the PREMISS. Indeed, the
PREMISS and CONCLUSION have no *necessary* connection with each other.
The fact that the CONCLUSION is true is not a matter of *correct logic;*
it's a matter of *good luck.* This point can be easily seen if we look at
the following example:

(4) Some people are not dittoheads.
 Therefore, some dittoheads are not people.

What (4) shows is that (3) is not an ARGUMENT that provides
conclusive proof of its CONCLUSION, even though that CONCLUSION
happens to be true. ARGUMENT (3), from the point of view of logical
correctness, is no better than (4).

Logical correctness, or VALIDITY, is a matter of the connection be-
tween the PREMISSES and the CONCLUSION; it's a matter of whether the
PREMISSES provide an appropriate amount of support for the CONCLU-
SION. Thus (now hang on to your hats), the following would be a logi-
cally correct ARGUMENT:

(5) Rush Limbaugh voted for Bill Clinton in '92.

 Therefore, Rush voted for someone whose last name begins
 with the letter 'C'.

Yes, the CONCLUSION (and the PREMISS) is almost certainly false.
But that's not the test of logical correctness. The point is that the
PREMISS of (5) provides complete support—despite being false—for
the CONCLUSION. We may express the matter this way: if (I said "if")
the PREMISS were true, the CONCLUSION could not possibly be false.

Now look back at ARGUMENTS (1) and (2). These are both, as we
have said, logically correct. But they are more than just logically

correct. They are also factually correct: they also have true PREMISSES. This additional feature makes them very special indeed, because such ARGUMENTS (with both features) have CONCLUSIONS that we really can rely on as true. But enough for now. We'll return to these topics when we come to VALIDITY—and especially COGENCY—a little later on.

What logic does is to spell out this idea of logical correctness (and related ideas) and formulate the laws of logic that define it. Remember, failure to attain logical correctness means fallacy, and one of the most important practical functions of the study of logic is the help it gives in enabling us to avoid fallacies in our own reasoning and to spot them in the reasoning of others—including, of course, the reasoning of talk show hosts. But before we can tackle that business, we need to develop some of the basic ideas of logic more fully.

ARGUMENTS

We reason whenever we marshal evidence to support a statement. For example, I might say

I know that the card was either a spade or a club because I saw that the card was black.

Here I am claiming that the card was either a spade or a club on the basis of the evidence that the card was black. We could also perform the same reasoning by saying:

The card was black, so it must have been either a club or a spade.

In both versions I am making an ARGUMENT in which I am claiming that a bit of evidence, called a PREMISS, supports another statement, called a CONCLUSION. To put it another way, I can also say that in both versions I am drawing an inference (the CONCLUSION) on the basis of evidence (the PREMISS). I realize that everybody already knows about PREMISSES and CONCLUSIONS from our discussion a few pages back. But I want to stress that these are *essential* ingredients in an ARGUMENT: **there cannot be an ARGUMENT without PREMISSES (at least one) and a CONCLUSION** (although the CONCLUSIONS and PREMISSES can sometimes by unexpressed or implied. But that's another matter).

Generally, when we reason and give reasons for something, we are making an ARGUMENT in which one or more statements (called PREMISSES) are offered to support (prove, provide evidence for) some other statement (called the CONCLUSION).

There is another feature that is very important when it comes to ARGUMENTS, and that is the little words or phrases that help us see that there is an ARGUMENT occurring and enable us to see which parts are PREMISSES and which are CONCLUSIONS.

Argument indicators

ARGUMENTS frequently, though not always, contain words or phrases called ARGUMENT INDICATORS which indicate that an ARGUMENT is occurring. We've already seen these things in our examples above about the cards. There the INDICATORS are 'because' and 'so'. (In our earlier examples (1)–(5) we used the indicator 'therefore'.) Indicators like 'because' *introduce evidence or* PREMISSES and, not surprisingly, are called PREMISS INDICATORS. The following list contains some, but not all, frequently encountered PREMISS INDICATORS:

because
since
for
inasmuch as
for the reason that
due to the fact that
as
after all

INDICATORS like 'so' and 'therefore' which *introduce a* CONCLUSION are called CONCLUSION INDICATORS. Here are some frequently seen CONCLUSION INDICATORS:

so
therefore
thus
hence
it follows that

we may conclude that
accordingly
for that reason

ARGUMENT INDICATORS are very important in indicating the *structure* of the reasoning, in determining which statements are PREMISSES and which are CONCLUSIONS. The absence of ARGUMENT INDICATORS may mean that there is no ARGUMENT occurring. Consider the following (courtesy of the seventeenth-century French talk show host René Limbaugh; any resemblance to the French philosopher and mathematician, René Descartes of that same period is purely coincidental):

(1) It's true that I talk, <u>therefore</u> it's true that I exist.

Here the CONCLUSION INDICATOR 'therefore' shows that "It's true that I exist" is the CONCLUSION from "It's true that I talk." (Note, by the way, that this is a good argument—the PREMISS does provide conclusive evidence for the CONCLUSION. A person can't talk without existing; it's not possible.) But notice:

(2) It's true that I talk, <u>because</u> it's true that I exist.

Here the premiss indicator 'because' shows that "It's true that I exist" is a premiss, not a conclusion as in (1). (Note that this is not a very good argument—the premiss does not provide conclusive evidence for the conclusion. A person can exist without necessarily having to talk; it is possible. [I know what you're thinking; but he only *seems* like a counterexample.]) Also notice:

(3) It's true that I exist, <u>because</u> it's true that I talk.

In (3) the PREMISS INDICATOR 'because' shows that "It's true that I talk" is a PREMISS for "It's true that I exist" (the CONCLUSION). Thus, (1) is the same ARGUMENT as (3), since they have the same PREMISS and the same CONCLUSION. But now consider:

(4) It's true that I talk, and it's true that I exist.

In (4) there is *no* ARGUMENT. The "and" is not indicating an ARGUMENT: there is no claim that one statement supports (is evidence for)

another. (4) merely consists of two separate statements joined by the word 'and'.

A word of caution about ARGUMENT INDICATORS. Words commonly used as INDICATORS may not always be so used. Take the word 'since'. This word is being used as an ARGUMENT INDICATOR only if it is being used to indicate a reason (PREMISS) for some assertion. It is not being so used if it functions merely as an adverbial preposition indicating a period of time up to the present. These two uses are illustrated below:

(5) The cherry trees will be in blossom next month since they always bloom in May.

(6) I haven't seen the cherry trees in blossom since the summer of '82.

In (5), 'since' functions as an ARGUMENT INDICATOR, and we have an ARGUMENT occurring. But not in (6). In (5) the word 'since' shows that a CONCLUSION is being drawn from the fact, or alleged fact, that the cherry trees always bloom in May. In (6), the word 'since' merely refers to a succession of events in time.

Arguments with Multiple Premisses

Some ARGUMENTS have many PREMISSES. Often such arguments will make use of several argument indicators which are underlined below. (Notice also that (7)–(10), besides having more than one PREMISS, are different ways of stating the *same* ARGUMENT, that is, they all have the same CONCLUSION and the same PREMISSES.) Thus:

(7) Abortion is wrong, <u>since</u> abortion is killing and all killing is wrong.

(8) Abortion is killing, <u>so</u> abortion is wrong <u>since</u> all killing is wrong.

(9) <u>Inasmuch as</u> all killing is wrong, <u>it follows that</u> abortion is wrong <u>because</u> abortion is killing.

(10) <u>Since</u> abortion is killing, and <u>since</u> all killing is wrong, <u>we can only conclude that</u> abortion is wrong.

(7)–(10) are superficially different versions of the *same* ARGUMENT. Its PREMISSES are: "Abortion is killing" and "All killing is wrong"; its CONCLUSION is "Abortion is wrong," We can represent this ARGUMENT very simply as:

(11) Abortion is killing.
 All killing is wrong.
 ↓ Abortion is wrong. ("↓" indicates the conclusion)

It is worth mentioning at this point that a different ordering of the PREMISSES would not result in a different ARGUMENT. That is,

(12) All killing is wrong.
 Abortion is killing.
 ↓ Abortion is wrong.

is the same ARGUMENT as (11) above.

Arguments with Missing Parts

ARGUMENTS are sometimes worded in ways which leave out parts of the argument. PREMISSES, CONCLUSIONS, or INDICATORS can be missing from the actual wording of the ARGUMENT, even though they are expected to be understood by the reader or listener.

Take ARGUMENT INDICATORS. Sometimes the claim of support (and there must be a claim of support if there is an ARGUMENT) is *implied or understood,* rather than explicitly stated. Suppose that someone said the following:

(13) Clinton is bound to make mistakes. He's only human.

In (13), the situation or context in which it was said might make it clear that what the speaker intends is to give a reason for asserting that Clinton is bound to make mistakes. As such, (13) could be thought of as containing an unexpressed PREMISS INDICATOR between the first and second statements, as in

(14) Clinton is bound to make mistakes. After all, he's only human.

So understood, (13) would be an ARGUMENT: the first statement would be the CONCLUSION; the second, the PREMISS.

Sometimes ARGUMENTS can lack stated CONCLUSIONS as well as IN-DICATORS. Consider the following:

(15) All humans make mistakes, and remember, Bill Clinton is human.

Notice that (15) contains neither an INDICATOR nor a CONCLUSION. Yet it would be reasonable in certain contexts to take (15) as intending to imply (without explicitly stating), as a CONCLUSION, 'Bill Clinton makes mistakes'.

And, less surprisingly, ARGUMENTS sometimes omit PREMISSES. Omitted PREMISSES are really quite common. This is especially true when a needed piece of information is already common knowledge. Consider the following:

(16) All men are mortal. So, Castro won't be around forever.

This is hardly an inference which we would want to question. But strictly speaking, the CONCLUSION doesn't follow unless we assume as an additional PREMISS that *Castro is a man*. Of course, we all do accept this as common knowledge and, so, don't bother to express it explicitly as a PREMISS in the ARGUMENT. It is, then, an unexpressed or implied PREMISS.

Complex Arguments

The ARGUMENTS we have looked at so far have been simple: they have consisted of PREMISSES claiming to support a CONCLUSION. But sometimes the reasoning is complex. Sometimes reasons are given for reasons; and sometimes CONCLUSIONS are drawn from CONCLUSIONS. In these cases we have COMPLEX ARGUMENTS. Here's an example of *reasons given for reasons:*

(17) Only a fool would vote for Clinton in '96. I say this because he simply can't be trusted to keep his word. Remember, he broke about every promise he made in the campaign of '92.

The same argument could be expressed somewhat differently in terms of drawing a CONCLUSION from a CONCLUSION:

(18) **Clinton broke about every promise he made in the campaign of '92. This obviously shows that he can't be trusted to keep his word. And therefore only a fool would vote for him in '96.**

Each of these versions may be reconstructed as a complex ARGUMENT comprised of two simpler ARGUMENTS in which *the CONCLUSION of one becomes a PREMISS for the CONCLUSION of the other:*

Argument 1
PREMISS: **Clinton broke about every promise**
CONCLUSION: **Clinton can't be trusted**

Argument 2
PREMISS: **Clinton can't be trusted**
CONCLUSION: **Only a fool would vote for Clinton.**

We can show the complex ARGUMENT even more simply and directly as:

Clinton broke about every promise
↓ Clinton can't be trusted
↓ Only a fool would vote for Clinton.

(Notice that the second ARGUMENT in this complex assumes, as an unstated PREMISS, that 'Only a fool would vote for a candidate who can't be trusted'—a seemingly true statement, but one which would be unacceptable if the candidate's opponents were even less trustworthy or otherwise flawed.)

DEDUCTIVE AND INDUCTIVE ARGUMENTS
Deductive Arguments

As we have already seen, all ARGUMENTS try to provide support (or evidence, or proof) for their CONCLUSIONS. Whenever an ARGUMENT tries to provide *complete* support, it is a DEDUCTIVE ARGUMENT. Often the ARGUMENT will make it quite obvious that it intends complete support by using phrases like 'so *necessarily . . .*' and 'so it *must* be that . . .' Here's an example of a DEDUCTIVE ARGUMENT:

(19) Smith is an uncle. So, necessarily, Smith is male.

Sometimes without phrases like 'so necessarily' it's difficult to tell whether the ARGUMENT intends to provide complete support or not. In such cases one must look and see how much evidence the PREMISSES actually do provide. If the support is complete, one can assume that such is the arguer's intention, and the ARGUMENT may be taken as a DEDUCTIVE one. All our above ARGUMENTS may be taken as DEDUCTIVE.

Deductive Validity

If a DEDUCTIVE ARGUMENT really does what it tries to do—if it really does provide complete support for its CONCLUSION (even if the PREMISSES offered for support are not actually true)—then we can say that it is DEDUCTIVELY VALID. Here's an example of a VALID DEDUCTIVE ARGUMENT:

(20) All dogs can fly. Garfield is a dog. Therefore, Garfield can fly.

An equivalent way to describe a DEDUCTIVELY VALID ARGUMENT is to say that in such an ARGUMENT, if the PREMISSES were true, the CONCLUSION could not possibly be false. All our ARGUMENTS numbered above, except (3) and (4) on page 4 and (2) on page 7, are (or can be, if we supply plausible PREMISSES) VALID DEDUCTIVE ARGUMENTS.

INDUCTIVE ARGUMENTS

If an ARGUMENT intends to provide only *partial* support for its conclusion, it is an INDUCTIVE ARGUMENT. Often the ARGUMENT will contain phrases like 'so probably . . .' to indicate that only partial support is being claimed. Usually the arguer will intend to claim a certain *degree of support* for the conclusion; if the PREMISSES are true and do support the conclusion to the degree claimed, then we can say that the conclusion follows from the PREMISSES *with a certain degree of probability.* Sometimes INDUCTIVE ARGUMENTS are called PROBABILISTIC ARGUMENTS. Here's an example of an INDUCTIVE ARGUMENT:

(21) John's gun was found at the scene of the crime, and his fingerprints were on the gun. So, probably, John did it.

Let's put the argument into its barest PREMISS-CONCLUSION form and indicate that it is an INDUCTIVE ARGUMENT by including the word 'probably' in parentheses:

(22) John's gun was found at the scene of the crime.
John's fingerprints were on the gun.
↓ (probably) John did it.

Sometimes an argument's support claim is unclear, and it is difficult to tell whether the arguer intends to provide complete support (and reason deductively) or partial support (and reason inductively). For example:

(23) The sun has risen every morning since humans have been on this planet. So obviously, the sun will rise tomorrow.

Although the arguer's language ("so obviously") could indicate either an INDUCTIVE or a DEDUCTIVE support claim, it would be uncharitable to interpret it as a DEDUCTIVE claim, since the PREMISSES, at best, make the CONCLUSION merely probable. This is so because past patterns of nature cannot be projected into the future with absolute (deductive) certainty. No matter how many times it has risen in the past, it is always *possible* that the sun will fail to rise tomorrow. (It's *possible* that the sun or earth could blow up; it's *possible* that the laws of nature could change; it's *possible* that God, if there is a God, will suddenly call a halt to His Cosmic Show.) So (23) is best construed as INDUCTIVE:

(24) The sun has risen every morning since humans have been on this planet.
↓ (probably) The sun will rise tomorrow.

Inductive Validity

INDUCTIVE VALIDITY is a matter of logical correctness as applied to INDUCTIVE ARGUMENTS. In other words it's a matter of whether the PREMISSES do provide the degree of support claimed.*

*Some logicians prefer to reserve the terms 'valid' and 'invalid' for deductive arguments only, inductive arguments being 'strong' or 'weak'. This has the merit of using

Since an INDUCTIVE ARGUMENT makes a claim of a certain degree of (partial) support for its CONCLUSION, we may say that it is INDUCTIVELY VALID when that claim of support is true, which means: when the PREMISSES really do provide the degree of support claimed. For example, if ARGUMENT (21) intends to claim a high degree of support such as would be necessary to convict someone in a U.S. court of law, then it would not be INDUCTIVELY VALID because the evidence almost certainly is not strong enough to convict John (especially if there were no eye-witnesses, other fingerprints on the gun, and so forth). But if the ARGUMENT is put forward only to *indict* John, then the claim of support need not be high, and the ARGUMENT stands a much better chance of being INDUCTIVELY VALID.

Although, as example (21) shows, it is possible to have a weak, but logically correct (VALID) INDUCTIVE ARGUMENT, we will find it most useful to apply the term INDUCTIVELY VALID to only those ARGUMENTS whose PREMISSES do provide strong support for their CONCLUSIONS.

Obviously, the standards for VALID INDUCTIVE reasoning, unlike DEDUCTIVE reasoning, are relatively vague. Often the degrees of support can't be quantified, and the PREMISSES can only be said to provide 'strong', 'moderate', or 'weak' support. And the standards are by no means universally agreed upon, although probability theory and statistics have been adapted to some kinds of INDUCTIVE reasoning with great success. But the main idea of VALID INDUCTION is that of learning from experience and projecting noticed regularities onto future experience. The ARGUMENT above about the sun rising is a good example.

In a VALID INDUCTIVE ARGUMENT the PREMISSES do afford an appropriate degree of support for the CONCLUSION and do make it probable (relative to the PREMISSES). But, unlike deductive validity, such an argument *may have a false conclusion even though the PREMISSES are true*. Consider:

different names for different standards of logical correctness and thereby discouraging possible confusion. Our terminology has the merit of avoiding an unnecessary proliferation of terms and should cause no trouble so long as we remember that the two kinds of validity are different.

(25) I have heard Rush Limbaugh on the radio every week day at noon for the last three months.
↓ (probably) If I tune in this Friday at noon, I'll hear Rush.

This ARGUMENT is INDUCTIVELY VALID; the PREMISS really does provide the CONCLUSION with a high degree of support even though the CONCLUSION *might* turn out to be false: I might turn on my radio and find, to my surprise, that Rush wasn't on.

There are several varieties of inductive reasoning. Here we will look at three frequently encountered sorts.

INDUCTION BY ENUMERATION

This is one of the simplest forms of INDUCTION. It is also known as *generalization*. In this pattern of reasoning, we note in the PREMISSES that many things that have been identified to be A's have also been observed to have some characteristic C and no cases of A's not having C have been observed. And from this we generalize that (probably) all A's have C. For example:

(26) Crows (so far observed for a finite number of cases) have been found to be black.
No non-black crows have been observed.
↓ (probably) All crows are black.

INDUCTION by enumeration can be risky, and in general, the greater the number of observed cases, and the greater the degree of dissimilarity between them, the more likely will be the CONCLUSION. Thus, the larger the number of observed crows in a wide variety of cases, the greater the probability that all crows are black.

INDUCTION BY ANALOGY

There are several variations of this kind of INDUCTION, but the essential idea is that of drawing a CONCLUSION that a certain thing has a certain characteristic because it is known to be very much like other things already known to have the characteristic. The simplest version of this reasoning is based on the similarities of two things and has the following pattern:

(27) Object A and object D are known to be alike in having characteristics C1, C2, and C3.
Object A is also known to have characteristic C4.
↓ (probably) Object B has characteristic C4 too.

This sort of reasoning is useful in science in suggesting likely causal connections as when we reason that, since a certain substance causes genetic damage in mice, therefore it probably can cause genetic damage in humans too. It's also useful in legal and moral reasoning—as when we reason that action X is wrong because it is like action Y, already admitted to be wrong—as well as in everyday life. It I reason from the fact that Rush's first book was funny to the CONCLUSION that probably his second book (which I know to be similar in many ways to the first) will be funny as well, I reason by analogy. Generally speaking, the more similarities A and B have in common, the fewer dissimilarities between them, the more probable it is that a characteristic possessed by A will also be possessed by B. Here's an example of a pretty good ARGUMENT by analogy.

(28) Twins, Ike and Mike, are alike in many ways.
Ike has poor hearing.
↓ (probably) Mike does too.

This ARGUMENT is good provided that we haven't overlooked any important dissimilarities that could spoil the inference. Thus, for example, if Ike, but not Mike, has had a job involving prolonged exposure to loud noise, the inference about Mike's hearing is thereby weakened. We'll have more to say about reasoning by analogy, and how it can go wrong, when we come to FALLACIES.

STATISTICAL INDUCTION

Sometimes our examined cases (our sample population) reveal that not all A's have C, and, consequently, we cannot draw the inference that the next A will have C by enumeration or analogy. But since a certain *percentage* of our examined cases have C, we can conclude that (probably) approximately that percentage holds in the entire population, including A's not yet observed. Here's an example:

(29) A survey of 1,000 Americans found that 250 smoke cigarettes.
↓ (probably) about 25 percent (within a certain margin of error) of Americans smoke cigarettes.

Notice that the strength of ARGUMENT (29) increases as the CON-CLUSION becomes less precise. Thus, the premiss makes it more likely that *between 20 and 30 percent* of Americans smoke cigarettes than that *exactly 25 percent* do.

Each of the above three kinds of INDUCTIONS is useful in our everyday reasoning, and although they are models for good INDUCTIVE reasoning, these methods can be risky if certain precautions are not taken. Here are two rules of thumb to help avoid weak INDUCTIONS.

1. We want our samples to be *sufficiently large.* The greater the sample size of the observed individuals the greater the probability of the CONCLUSION, other things being equal. As we shall see in our discussion of FALLACIES, a sample that is too small will not provide sufficient evidence to warrant the CONCLUSION. In our smoking example, obviously the CONCLUSION would be less reliable if we had surveyed only four people and found one smoker.

2. We want our samples to be *representative.* The more representative the sample (observed) population is of the whole population, the more reliable are the inferences about the rest of the population. Usually, the larger the sample size, the more representative it will be of the whole. Thus, the more crows that are observed and found to be black, the more likely it is that we will not overlook any individuals that could be an exception to our generalization. But, of course, there is no guarantee that even a large sample will be representative of an entire population. In our smoking example, even if the survey was of 10,000 Americans, the inference would be weakened if all those surveyed were from one region of the country, or in one age group, or in one socio-economic class. This is because we know (on the basis of our experience and INDUCTIVE reasoning) that social behaviors and habits often vary with geographical location, age, and social status.

HIGHER-LEVEL INDUCTIONS

One of the features of INDUCTIONS is their sensitivity to higher-level generalizations. Consider the following:

(30) **Every year since he was a little boy, George Burns has celebrated his birthday.**
 January 20th, 1996, will be George Burns's 100th birthday.
 ↓ (probably) On January 20th, 1996 George Burns will celebrate his birthday.

This is a valid application of INDUCTION by analogy. (Similar things [January 20ths] have similar characteristics [birthday celebrations].) The PREMISSES do provide some support for the CONCLUSION. But the CONCLUSION is nevertheless risky because of well known higher-level INDUCTIONS about human longevity: as people get older, their chance of dying increases, and people rarely live to be 100. These higher-level INDUCTIONS over-ride the simple inference from analogy in (30) and suggest that its CONCLUSION is not very probable. If we were to overlook these higher-level INDUCTIONS, as (30) does, or if we were to omit any other relevant information (such as a recent failure of health), we would commit the INDUCTIVE fallacy of SUPPRESSED EVIDENCE. (See Chapter 2, pages 44–48.)

COGENT REASONING

The point of reasoning, DEDUCTIVE or INDUCTIVE, is to establish a CON-CLUSION as true or probably true. As we have seen, ARGUMENTS that are VALID, whether DEDUCTIVE or INDUCTIVE, do not ensure that their CONCLUSIONS are true. They merely ensure that the CONCLUSION fol-lows (necessarily or probably) from the PREMISSES. To ensure such CONCLUSIONS, ARGUMENTS must be more than VALID; they must be CO-GENT. The standards of COGENCY, like those of VALIDITY, are somewhat different for DEDUCTIVE and INDUCTIVE ARGUMENTS.

DEDUCTIVE COGENCY

A DEDUCTIVE ARGUMENT is COGENT provided:

1. It is DEDUCTIVELY VALID, and

2. All the ARGUMENT's PREMISSES are warranted.

We have already looked at the idea of VALIDITY as applied to DE-DUCTIVE ARGUMENTS. And we have seen that, as in (20) above, it provides no sufficient reason to accept the CONCLUSION as true. What is also needed is that *the* PREMISSES *all be warranted,* or in other words: that we have, or could provide, strong evidence to believe them true. Here's an example of a DEDUCTIVELY COGENT ARGUMENT (courtesy of Aristotle—with some slight modification):

(31) All men are mortal.
Rush Limbaugh is a man.
↓ Rush Limbaugh is mortal.

In this example, the ARGUMENT is COGENT: it is VALID (those who have been paying close attention will recognize it as the same ARGU-MENT as (1) given earlier); and the PREMISSES are *warranted* in the sense that we have good reason to believe them true.

There are a couple of points about the idea of warranted PREMISSES that should be kept in mind. If a PREMISS is warranted that means roughly that the evidence justifies our belief in it. This is not quite the same as saying that the PREMISS is true, but generally speaking, justified beliefs stand a better chance of being true than unjustified beliefs. Of course, not all evidence has equal weight in the justification of our beliefs. Reasonable people can differ over their assessment of the evidence and, therefore, on the question of whether a PREMISS is warranted.

The requirement that the PREMISSES be warranted really amounts to saying that we could provide separate (cogent) ARGUMENTS for them if we had to. Both INDUCTIVE and DEDUCTIVE reasoning might be used in justifying our PREMISSES. In our DEDUCTIVE ARGUMENT above about Rush Limbaugh's mortality, the first PREMISS could be justified by simple INDUCTIVE enumeration. That is, we could construct a separate COGENT ARGUMENT for the generalization about all men's mortality on the basis of the large number of observed individual deaths. (Of course, dittoheads might be tempted to save time in this case, as in all others, by simply asking Rush for the truth about the matter. Since, according to his own assessment, Rush is right 97.9 percent of the time [*The Way Things Ought to Be,* p.43], it's thought highly probable that whatever he *says* is true, *is* true. We might call this the

'Rush says' theory of warrantability. It is, however, a controversial theory, and I must admit that I am skeptical. But I'll say this much for it: it's simple.)

It goes without saying that this second requirement of COGENCY is often a tough one to fulfill. It places great demands on the would-be COGENT reasoner which go beyond the traditional, but narrow, boundaries of VALID reasoning. In short, the COGENT reasoner must know more than how to judge whether the CONCLUSION follows from and is supported by the PREMISSES. He/she must also know how to judge the truth of claims about the world generally.

Inductive Cogency

An INDUCTIVE ARGUMENT is COGENT provided:

1. It is VALID (with strong support for the CONCLUSION), and
2. All its PREMISSES are warranted, and
3. No relevant information has been omitted.

The third requirement needs some explanation. Recall that the essential feature of INDUCTIVE ARGUMENTS is their claim of partial support for the CONCLUSION by the PREMISSES. This means that an INDUCTIVE ARGUMENT is VALID if the PREMISSES provide the degree of partial support claimed for the CONCLUSION, or in other words: if the conclusion follows with an appropriate degree of *probability*, rather than with *necessity* as in the case of VALID DEDUCTIVE ARGUMENTS. The following INDUCTIVE ARGUMENT is VALID:

> (32) **Ninety-four percent of males between 45 and 54 are, or have been, married.**
> **Smith is a 50-year-old male.**
> ↓ **(probably) Smith is, or has been, married.**

Let's assume that the PREMISSES are warranted. The ARGUMENT looks pretty good. But it may still fail to be COGENT if any relevant information has been left out—information which, if taken into account, would significantly weaken the support for the CONCLUSION and, therefore, our confidence in its truth. Knowing whether information is relevant or not is often very difficult. Indeed, one of the distinguishing char-

acteristics of a good critical thinker is being able to recognize certain things as relevant when others would fail to see a connection. If, to take an obvious example, Smith is a Catholic priest, that fact would be highly relevant to the COGENCY of the above ARGUMENT since it is well-known that few Catholic priests are, or have been, married. Such information added to (32) would indeed significantly weaken the support for the CONCLUSION. Accordingly, (32) would be NONCOGENT.

The fact that COGENCY may be spoiled by the omission of relevant evidence is a problem for INDUCTIVE reasoning only. This is because the CONCLUSION of a VALID DEDUCTIVE ARGUMENT must be warranted if the PREMISSES are warranted. No additional relevant information could make any difference to the (complete) degree of support which the PREMISSES already provide. Of course, new information could cause us to change our minds about whether the PREMISSES are all actually warranted. But that is really a concern falling under the second requirement for COGENCY rather than the third.

From what we have said in this section, the cogency of INDUCTIVE ARGUMENTS will be a matter of degree and, like INDUCTIVE VALIDITY, somewhat vague and imprecise.

We are now almost ready to have a look at Rush's reasoning (including several dozen NONCOGENT ARGUMENTS). Indeed, we shall get about that business in Chapters 3–9. But first let's talk a little about FALLACIES.

How to Spot Fallacies

Ways To Go Wrong

In everyday parlance, people often use the term FALLACY to mean a mistaken belief or idea. For example, we might hear that it is a FALLACY to believe that handling a toad will cause warts, or that margarine is healthier than butter, or that most poor people don't work, or that higher tax rates mean more revenue. These beliefs, whether true or not, are not what we will understand by FALLACY. What we mean by the term is a bad bit of reasoning. More precisely, **a FALLACY is an ARGUMENT which is not COGENT.**

THREE CATEGORIES OF FALLACY

From our discussion in the previous section, we know that an ARGU-MENT can fail to be COGENT in three ways: the reasoning can be IN-VALID; the PREMISES can be unwarranted; and, in the case of INDUC-TIVE reasoning, the PREMISES can omit relevant evidence. Corresponding to these three sources of NONCOGENCY we can distinguish three types of FALLACIES:*

1. **FALLACIES of INVALIDITY**
2. **FALLACIES of unwarranted PREMISS**
3. **FALLACIES of omitted evidence**

Under each of these general categories we shall briefly discuss some well-known FALLACIES. In fact some FALLACIES are so well-known—their pattern of error so frequent in the history of human discourse—that they have been given names. Logicians have catalogued several hundred different kinds. All, however, fall under one or other of the three general sorts of errors mentioned above (INVAL-IDITY, unwarranted PREMISES, omitted evidence). Some FALLACIOUS reasoning may commit more than one of these errors at a time. For example, an ARGUMENT could have unwarranted PREMISES and be IN-VALID. In practice, this means a certain amount of overlap among the subcategories of FALLACIES, and we should not be surprised to find that a single piece of reasoning may exhibit several FALLACIES at once.

FALLACIES OF INVALIDITY

Generally, whenever an ARGUMENT's CONCLUSION does not follow from its PREMISES in accordance with its claim of support, there will be a FALLACY of INVALIDITY committed. The term *non sequitur* (from the Latin, meaning 'does not follow') is sometimes applied to ARGUMENTS with this kind of mistake.

Some DEDUCTIVE ARGUMENTS commit FALLACIES OF INVALIDITY ow-ing to the *logical form* of the reasoning, quite apart from the content

*The three-part classification of informal fallacies developed in this chapter borrows heavily from Howard Kahane's treatment in his *Logic and Contemporary Rhetoric* (7th edition; Wadsworth, 1995).

or meaning of the argument. These sorts of FALLACIES OF INVALIDITY based on form are known as *formal* FALLACIES and should be distinguished from *informal* FALLACIES.

Formal FALLACIES are important and interesting in their own right, but our focus will be on the *informal* FALLACIES, since they will provide us with the most useful tools for dealing with contemporary rhetoric generally and Rush Limbaugh's rhetoric in particular. But before we move on to the informal FALLACIES OF INVALIDITY, let's try to understand, in at least a rudimentary way, what we mean by a *formal* FALLACY. We'll consider two examples.

First, let's take one of our earlier examples (of a logically incorrect ARGUMENT):

(1) Some dittoheads are not gun owners.
↓ Some gun owners are not dittoheads.

Its form, or logical skeleton, is:

(2) Some A's are not B's
↓ Some B's are not A's.

The science of DEDUCTIVE logic tells us that (1) is invalid because of its INVALID form. And the form is INVALID because it fails to guarantee the truth of the CONCLUSION in all instances where the PREMISS is true. The following example provides an instance of the form where the PREMISS is true but the CONCLUSION is false.

(3) Some U.S. citizens are not U.S. Senators.
↓ Some U.S. Senators are not U.S. citizens.

ARGUMENT (3) shows quite clearly that the form of (1) is defective—and that ARGUMENT (1) is INVALID—since it allows the possibility of true PREMISSES leading to a false CONCLUSION, something that no VALID form can allow (by definition). (The FALLACY committed, if you must know, is the FALLACY OF ILLICIT CONVERSION OF AN O PROPOSITION. Don't ask what it means now. You don't need to know, not for the level of logic dealt with in this book.)

Consider one more case of INVALIDITY due to form:

(4) If Mozart wrote *Hamlet,* then he was a great playwright.
Mozart did not write *Hamlet.*
↓ Mozart was not a great playwright.

If you must know the invalid form of (4) is:

(5) If p, then q
Not-p
↓ Not-q

That this form is defective is made clear by the following instance:

(6) If Rush Limbaugh wrote *The Firm,* then he is a popular author.
Rush Limbaugh did not write *The Firm.*
↓ Rush Limbaugh is not a popular author.

As in (3), the example shows that the form is INVALID since the PREMISSES are true but the CONCLUSION is false. (By the way, the formal FALLACY exhibited in (4) and (6) is known as the FALLACY OF DENYING THE ANTECEDENT.)

There is yet another point to notice about our examples (1) and (4). Although they are FALLACIOUS, their CONCLUSIONS are not false. The lesson to take here is that **a FALLACIOUS ARGUMENT needn't have a false CONCLUSION.** (I know the point was already made in our earlier discussion of (3)–(5) in Chapter 1. But it's an important point, and a little repetition can't hurt.) In fact, it would be a FALLACY OF INVALIDITY to argue that since some ARGUMENT is NONCOGENT, its conclusion must be false. (Do you see why?)

Argument from Ignorance

The FALLACY OF ARGUMENT FROM IGNORANCE is committed when we reason that a statement is false (or true) from lack of conclusive evidence that it is true (or false).

PREMISS: **Says that a statement has not been proved true (or false).**

CONCLUSION: **Says that the statement is false (or true).**

This FALLACY frequently occurs in popular disputes about controversial issues on the edge of science. Thus, someone might reason

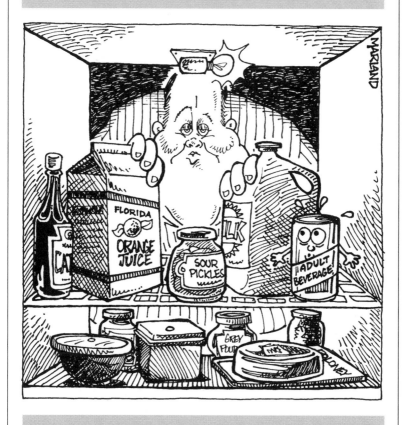

that ESP (telepathy) is a fact, since no one has ever disproved it. Of course, an equally FALLACIOUS ARGUMENT would be to reason that ESP must not be a fact because it has not been proven to be a fact.

Often, beginning philosophy students are disturbed by the prospect that the traditional ARGUMENTS for the existence of God may not be cogent, because they think that a FALLACIOUS ARGUMENT must have a false CONCLUSION and that, therefore, if an ARGUMENT for God's existence is FALLACIOUS, then God could not exist. Of course, no such CONCLUSION follows. There might be any number of bad arguments for the existence of God, and God might exist all the same. (It's true that a FALLACIOUS ARGUMENT fails to establish the truth of its conclusion. But it does not, on that account, establish the falsehood of its CONCLUSION. Indeed, just think of any statement you know to be true, and you can easily come up with a FALLACIOUS ARGUMENT for it.) The reasoning of these students could be represented as follows:

(7) These arguments for the existence of God are fallacious.
 ↓ God does not exist.

This ARGUMENT (7) is an instance of the FALLACY of ARGUMENT FROM IGNORANCE. We should add that, no matter whether (7) is taken DE-DUCTIVELY or INDUCTIVELY, the CONCLUSION does not follow from the PREMISS. The ARGUMENT is INVALID.

Let's look at one more example of the FALLACY, an example of some historical importance. Thirty years ago, the US Surgeon General announced the availability of the oral contraceptive, and he endorsed its use for those women who so chose (in consultation with their physicians), adding, in response to a question about safety: "There is no evidence that the oral contraceptive is harmful to human health." Many people took him to be implying that The Pill was safe. Accordingly, the reasoning could be represented as:

(8) There is no evidence that The Pill is harmful.
 ↓ The Pill is safe.

In fairness to the Surgeon General, he did not explicitly draw the CONCLUSION that The Pill was safe, and he may have known better than to imply it. (He certainly should have known better, given the

relatively small amount of data available and its controversial nature.) But in the context of his answer, and given that the FDA had approved The Pill, he may reasonably be taken to imply the CONCLUSION in question. That is, he committed the FALLACY OF ARGUMENT FROM IGNORANCE. (Whether the many Americans who accepted this bit of reasoning also committed the FALLACY is more doubtful, provided they didn't take the CONCLUSION to follow with DEDUCTIVE certainty. For them it would seem that the INDUCTIVE inference was warranted by the fact that it was being recommended by an appropriate expert in the field. We will look at the FALLACY OF APPEAL TO INAPPROPRIATE AUTHORITY a few pages below.)

The fact that no harmful effects had become evident at that time did not justify the CONCLUSION that The Pill was safe. Indeed, it later turned out that The Pill did have some harmful effects and was admitted not to be safe (at least not at the high hormonal dosages used in the early 1960s). Yet the Surgeon General's statement was strictly true since The Pill was relatively new and no large long-term studies had yet been completed.

This example should remind us that lack of evidence that something is so (that, for example, The Pill causes health problems) does not mean that it is not so. Yet, there are often cases where lack of evidence for the truth of some statement after an appropriate and thorough examination, does mean that it is (probably) false. Suppose Rush Limbaugh is looking in his refrigerator for an adult beverage (that would be a beer, as any proper dittohead knows). He might, after a careful but fruitless search, reason as follows:

(9) I have found no adult beverage in my refrigerator.
↓ There is no adult beverage in my refrigerator.

This is a good (COGENT) INDUCTIVE ARGUMENT because he knows (unexpressed PREMISS) that if there were any adult beverage in his refrigerator, it is very likely that a thorough search would reveal it. (It's not DEDUCTIVELY certain, mind you. Not even if Rush's refrigerator were very small with few shelves and stocked with few items— unlikely, I know, but don't quibble with the example. Even so, Rush could still be mistaken.)

Argumentum ad Hominem

This fallacy gets its name from the Latin, meaning 'at the man'. We commit the FALLACY OF ARGUMENTUM AD HOMINEM when we reject a person's reasoning or position by criticizing the person instead of the reasoning or the position.

PREMISS: **Makes an irrelevant attack on the person's character or circumstances.**

CONCLUSION: **Says that the person's reasoning or position is wrong.**

What makes this FALLACY a FALLACY is not the fact that the attack may be false, but rather that it is *irrelevant to the truth or* COGENCY *of the point at issue,* usually the position maintained or ARGUMENT made by the person attacked. Let's consider a few examples.

I don't see how you can believe that Karl Marx's theory of surplus-value makes any sense. Don't you know who Marx was? He was the father of that global abomination—Godless Communism.

It's not difficult to see what's going on here, despite the fact that there are no recognizable ARGUMENT INDICATORS. The speaker is rejecting Marx's theory of surplus-value by attacking Marx personally. Thus, the underlying reasoning could be reconstructed as:

(10) Marx was the father of that global abomination—Godless Communism
↓ Marx's theory of surplus-value makes no sense.

Even if the charge were true—and he is reputed to be the father of communism, whether global abomination or not—the charge is irrelevant to the point at issue, which is the truth of Marx's theory.

Sometimes the AD HOMINEM FALLACY makes an irrelevant reference to the opponent's special circumstances and takes those circumstances to discredit the opponent's position or reasoning.

General Baum has argued that Clinton's proposed cuts in the military budget are a bad idea for the U.S. economy. But why should we listen to the general? He knows that the cuts will hurt him and his military friends. His position is clearly self-serving.

In this example, the speaker is trying to get the audience to reject the general's message (We shouldn't listen to him) because of the self-serving nature of his opposition to the cuts. What's going on is essentially this:

(11) General Baum's opposition to Clinton's military cuts is self-serving.
↓ We can dismiss what he says against the cuts.

The primary issue here is not General Baum or his motives. The primary issue is the truth of *what he says* about Clinton's proposed military cuts. The fact that he may be biased against the cuts should make us look even more carefully at his reasons for opposing them. But even biased people can muster COGENT ARGUMENTS. And we can't properly dismiss what the general says until we have carefully considered what he says and appraised it by the standards of COGENT reasoning.

It is important to realize, however, that not all AD HOMINEM attacks are FALLACIES. The crucial point is that the attack be irrelevant to the CONCLUSION drawn or to the point at issue. Thus, for example, if I argue that Smith shouldn't be elected to office because he is a child molester, I make an AD HOMINEM attack, but there is no FALLACY (let's suppose my PREMISS is warranted) since the attack is relevant to the CONCLUSION.

Irrelevant Conclusion

This, like the previous errors, is a FALLACY OF RELEVANCE. But in this case the error consists in drawing a CONCLUSION that is irrelevant to the point at issue: the CONCLUSION drawn is irrelevant to the CONCLUSION that one is supposed to be proving.

PREMISS: **Makes a statement S (in the context of trying to establish a CONCLUSION, the point at issue).**

CONCLUSION: **VALIDLY draws a CONCLUSION from S, but not the CONCLUSION relevant to the point at issue.**

This FALLACY of relevance typically occurs in a legislative body where a member will rise to argue for or against a bill, but will actu-

ally argue for or against some other irrelevant proposition. For example, a Congressman, attempting to argue for funding for a particular weapon system, might make a very persuasive case that military spending is good for the economy, although that conclusion is strictly irrelevant to the question of whether this particular weapon system should be funded.

Sometimes AD HOMINEM attacks are also FALLACIES OF IRRELEVANT CONCLUSION. As we have seen, sometimes an attack on a person is irrelevant to the CONCLUSION being drawn. But sometimes, although the attack is relevant to a CONCLUSION which the arguer draws, the CONCLUSION drawn is a different one from the point at issue. When an attack takes this tack, it commits the FALLACY OF IRRELEVANT CONCLUSION.

Both kinds of attacks are found in the following (slightly adapted) exchange between Al Gore and (then Vice President) Dan Quayle:

Quayle: **Bill Clinton can't be trusted to tell the truth. He's deceived the American people time after time.**

Gore: **Dan, once again you're mistaken. Let's not forget who said "Read my lips; no new taxes."**

First of all, notice that Quayle's attack is relevant to the CONCLUSION he draws, which is that Clinton can't be trusted to tell the truth. No FALLACY here (unless it's UNWARRANTED PREMISS, but we will ignore that). The reasoning is:

(12) Clinton has deceived the American people many times.
↓ He can't be trusted to tell the truth.

The context establishes the point at issue as Quayle's charge that Clinton can't be trusted. And Gore seems to recognize this in his remark "Dan . . . you're mistaken." But notice how Gore continues. Instead of providing support for this statement, and making it the CONCLUSION to be justified, Gore chooses a counterattack on Bush (and, indirectly, on Quayle) by his reminder "Let's not forget who said 'Read my lips; no new taxes.'" Now this retort very cleverly implies the CONCLUSION that Bush broke his promise and (perhaps) can't be trusted. But this conclusion, even if cogently drawn, is irrelevant

to the point at issue; it's irrelevant to the CONCLUSION that Gore is required to establish, the CONCLUSION that Quayle's charge is false. In other words, the ARGUMENT that Gore makes looks like:

(13) Bush lied when he said "Read my lips . . ."
↓ Bush can't be trusted.

But the ARGUMENT he is required to make must have a different CONCLUSION:

(14) [Some appropriate PREMISS.]
↓ Quayle's charge about Clinton is false.

It is possible that Gore intends his conclusion in (13) as the basis for the conclusion in (14). If so, Gore's reasoning could be represented as:

(15) Bush can't be trusted.
↓ Quayle's charge is false.

This is not an uncharitable interpretation of Gore's reasoning. But notice that (15) is still a kind of AD HOMINEM attack which is irrelevant to the point at issue (whether Clinton is trustworthy). The moral of all this is that it's not FALLACIOUS to attack a person provided the attack is relevant to the CONCLUSION that you draw or are required to establish. Otherwise your attack could be an AD HOMINEM FALLACY or (and, in Gore's case) a FALLACY OF IRRELEVANT CONCLUSION.

Oh yes, one more point about IRRELEVANT CONCLUSIONS. This FALLACY can almost always also count as a case of EVADING THE ISSUE. The issue can be evaded by arguing for an irrelevant CONCLUSION. But it can also be evaded by refusing to make a proper ARGUMENT at all, for instance by mere name-calling or good old-fashioned obfuscation (your opponent throws the 'bull' in hopes that you'll forget what the issue is). Such a form of EVADING THE ISSUE can't strictly be called a fallacy (because there's no ARGUMENT), but it remains a frequently-used source of deception, and, in the context of informal logic, it should be counted as a kind of logical error.

Equivocation

This FALLACY arises because a word or phrase in the argument is used ambiguously, with more than one meaning. When we confuse the meanings with each other, we commit the FALLACY OF EQUIVOCATION. Usually the ambiguity occurs in the PREMISSES.

PREMISS: **Uses word or phrase ambiguously.**

CONCLUSION: **Makes a false statement due to ambiguity in PREMISSES.**

The FALLACY is difficult to explain, but often easy to spot, as in the following example:

Anyone with grass in his/her possession violates US drug laws. President Clinton has grass growing all around the White House. So, President Clinton violates the US drug laws.

The reasoning here is pretty obvious:

(16) Anyone in possession of grass violates the US drug laws.
 President Clinton has grass growing around the White House.
 ↓ President Clinton violates the US drug laws.

The error in (16) is also pretty obvious. The word 'grass' is used in two different senses. In the first PREMISS it is used as slang to mean *marijuana* (you know, the stuff that Clinton tried but didn't inhale); in the second PREMISS it is used to mean the ordinary green stuff that Clinton has to have mowed every week (and wouldn't do him any good if he did inhale it.)

Notice that if the word 'grass' is used to mean marijuana in both PREMISSES, THE ARGUMENT would be VALID. But in that case it would not be COGENT since the second PREMISS would be false: the president does not have marijuana growing around the White House. (I sense that there may be one or two dittoheads who have their doubts about that. No comment.)

Hasty Generalization

This FALLACY (and the related FALLACY OF QUESTIONABLE CAUSE) is a FALLACY due to insufficient evidence. One commits the FALLACY OF

HASTY GENERALIZATION when we reason from the fact that some (a few) things of a certain kind are such and such to the generalization that *all or most* things of that kind are such and such.

PREMISS: **Says that some (a few) A's are B's.**

CONCLUSION: **Says that all or most A's are B's**

The error lies in drawing a CONCLUSION that goes way beyond what the evidence will support, so that even taken INDUCTIVELY, the ARGUMENT will be weak and the reasoning INVALID. Here's an example:

Last month our mailman was bitten by a German Shepherd for apparently no reason at all. In last Friday's paper there was a story about a Shepherd that attacked two children without provocation. So it's obvious to anyone willing to face facts— German Shepherds are vicious.

In this example, the speaker is apparently giving evidence for the general claim that Shepherds (all or most) are vicious. The reasoning may be represented as:

(17) **Last month our mailman was bitten by a Shepherd.**
Last week a Shepherd attacked two children.
↓ All, or most, German Shepherds are vicious.

Obviously, the PREMISSES provide inadequate support for the CONCLUSION. We would need much more evidence than that afforded by two cases to establish the generalization.

Of course, if the arguer merely means to conclude that some Shepherds are vicious, there is no fallacy. But then the ARGUMENT would be trivial.

Here's an example that was far from trivial in the world of presidential politics. President Gerald Ford in his infamous debate with Jimmy Carter, responded to Carter's charge that the Ford administration had tolerated Russian domination of Eastern Europe:

There is no Russian domination of Eastern Europe as Governor Carter has alleged. There is none in Poland; there is none in Hungary; there is none in Yugoslavia.

In this example, Ford tries to justify the negative generalization (there is no Russian domination of Eastern Europe) by giving three instances. Here's his ARGUMENT:

(18) There is no Russian domination in Poland.
 There is none in Hungary.
 There is none in Yugoslavia.
 ↓ There is no Russian domination in Eastern Europe.

Quite apart from the question of whether his examples are truly instances of the absence of Russian domination in the countries mentioned, his examples are insufficient to establish the generalization with any degree of confidence. He needed to consider, at least, the other Warsaw Pact countries (East Germany, Bulgaria, Romania, and Czechoslovakia). And, in 1976, these countries, by almost any measure of domination, were dominated by the USSR.

In those cases where the inference is based on insufficient evidence but the CONCLUSION is not necessarily a generalization, some logicians like to use the label HASTY CONCLUSION.

Questionable Cause

We commit the FALLACY OF QUESTIONABLE CAUSE when we mistake something for a cause when it is not. Perhaps the most frequently encountered version of the FALLACY is the form known as POST HOC ERGO PROPTER HOC (from the Latin meaning 'after this therefore on account of this'). In this version, event A is inferred as the cause of event B solely on the evidence that A preceded B.

PREMISS: **Says that A occurred before B.**

CONCLUSION: **Says that A caused B.**

The FALLACY is committed, not because A is not the cause of B, but because the evidence does not warrant the inference. Here's an example about the medical effectiveness of vitamin C:

All I know is that vitamin C really does work for sore throats. Last night I had a severely sore throat. I took 1,000 mg. of vitamin C

and went to bed. When I awoke, guess what? My sore throat was completely gone.

In this reasoning, the speaker concludes that it was the vitamin C that caused her throat to feel better just because the throat felt better after she took the vitamin C. The ARGUMENT is essentially:

(19) My sore throat disappeared after I took vitamin C.
↓ Vitamin C caused my recovery from sore throat.

Of course, the recovery could be due to the vitamin C, but the evidence cited is insufficient to establish that with any degree of confidence. For all we know, the throat might have gotten better even more quickly without the vitamin, and the vitamin C may actually have retarded her rate of recovery.

(Notice, also that the original piece of reasoning seems to go beyond the question of the cause in this particular case. Indeed, it seems to imply that vitamin C is effective for sore throats generally ("Vitamin C does work for sore throats"). As such it also contains an inference from the alleged cure for the speaker's sore throat to a cure for sore throats generally. This would be a HASTY GENERALIZATION if we have no reason to believe that the sore throat that was allegedly cured by the vitamin C was typical of most sore throats. The point is that because of individual differences, one can't be confident, without further information, that what worked in one case, will also work in most cases. It may be that vitamin C's effectiveness is limited to a certain kind of sore throat representing a small subset of sore throats.)

Here's one more example worth looking at:

We can show quite convincingly that smoking marijuana leads to heroin addiction. The evidence is undeniable: 97 percent of heroin addicts first started with marijuana.

The structure of the argument is well marked. The evidence about heroin addiction and marijuana use is cited to establish the CONCLUSION that the latter causes ("leads to") the former. Thus:

(20) 97% of heroin addicts first started with marijuana.
↓ Using marijuana causes heroin addiction.

Here a certain kind of thing (marijuana use) is claimed to cause some other kind of thing (heroin addiction) on the basis of the evidence that the vast majority of the cases of the latter (heroin addiction) occurred after the occurrences of the former (marijuana use). The evidence in the PREMISS certainly shows a correlation between heroin addiction and marijuana use, but this is not ordinarily sufficient to show a causal connection between the two.

A much more important statistic to obtain is the percentage of marijuana users who go on to become addicted to heroin. (Answer: about 1 percent.) This figure puts the 97% into proper perspective. After all, it's also true that 100% of heroin addicts first used water. But this does not show that drinking water leads to heroin addiction.

Even if it turned out that a large percentage of marijuana users become heroin addicts, that would not necessarily be proof of a direct causal connection. After all, day always follows night, just as night is always preceded by day. But this does not show that day is the cause of night. Rather, both are the effects of a third factor, namely: the rotation of the earth in the vicinity of the sun. Similarly, it might be that certain types of individuals are extremely prone to trying all the psychotropic drugs they can get hold of. It would then be true that people of these types use both marijuana and heroin (and used marijuana first, let us suppose), but it would not be true that using marijuana *caused* anyone to use heroin. Marijuana use and heroin use would be linked (correlated), not because one caused the other, but because both were the effects of the same cause.

Correlations can be useful in the discovery of causes. If A causes B, there will be a correlation between the two. But the correlations can, and often do, occur in the absence of causal connection.

FALLACIES OF UNWARRANTED PREMISS

These FALLACIES are all sometimes known as FALLACIES OF QUESTIONABLE PREMISS. Within this general category there are several interesting subspecies.

Straw Man

We commit the FALLACY OF STRAW MAN when we mischaracterize our opponent's position in order to make it easier to refute.

PREMISS: **Says something untrue about an opponent or his/her position**

CONCLUSION: **Says opponent or position really is unworthy of our acceptance. (Conclusion may follow validly.)**

Often politicians are subject to attack in ways that so distort their ideas that their positions are barely recognizable. Here's an example:

How can any reasonable person vote for Bill Clinton? Clinton wants to raise the income tax rates on families earning less than $50,000, and he advocates unilateral disarmament for the U.S.

The speaker is clearly trying to establish that we shouldn't vote for Clinton because of his (allegedly) unreasonable position on taxes and disarmament. The structure of the ARGUMENT is:

(21) Clinton wants to raise income tax rates for families earning less than $50,000, and he advocates unilateral disarmament.
↓ No rational person should vote for him.

This is a STRAW MAN FALLACY because the characterization of Clinton's policies is inaccurate. Clinton has not advocated such views, so far as this writer is aware, certainly not in his 1992 presidential campaign or since.

Notice, however, that the ARGUMENT is VALID; the CONCLUSION does follow from the PREMISS, provided we assume, what most people would readily grant, that these policies are unreasonable and that a candidate who advocates them is unworthy of a rational voter's vote.

False Alternatives

The fallacy of false alternatives is committed when we consider only a few of the available alternatives, and we wrongly suppose that all but one of the considered alternatives are unacceptable.

PREMISS: **Says certain alternatives are available (but omits at least one acceptable possibility).**

PREMISS (often unexpressed): Says that all but one of the stated alternatives are unacceptable.

CONCLUSION (often unexpressed): Says that the remaining alternative must be accepted.

When the PREMISSES do really exhaust the possibilities of choice, no fallacy is committed. Thus, either today is Tuesday or it's not. This is a warranted PREMISS from which we could validly conclude that today is not Tuesday, provided we can rule out the first alternative (that today is Tuesday) as unacceptable. But the statement that either today is Tuesday or it's Wednesday would provide a false alternative when spoken on one of the other five days of the week, since it falsely rules them out as possibilities. Here's an example:

> **Look, when Limbaugh said that American soldiers had never before been under foreign command, what he said was either the truth or it was a lie. But Fairness and Accuracy in Reporting (FAIR) has shown that Limbaugh's statement is definitely not true. Obviously, therefore, it's a lie.**

In this example, the speaker (a mean-spirited liberal) is trying to convince us, by means of false alternatives—it's either the truth or a lie—that Rush's statement is a lie just because it's not true.

> **(22) Limbaugh's statement is either the truth or it's a lie.**
> **It's not the truth.**
> ↓ **Limbaugh's statement is a lie.**

The problem here is not the second PREMISS, which we will assume to be warranted. The problem lies with the first PREMISS which falsely assumes that a statement is either true or a lie. A lie is a falsehood known (by the person who utters it) to be untrue. Just because Rush's statement was *untrue* (even being right 97.9 percent of the time allows for some error), does not mean that it was a *lie*—that he *knew* it was untrue. The first PREMISS wrongly excludes a third possibility: that Rush's statement was simply an honest error, neither the truth nor a lie.

The FALLACY OF FALSE ALTERNATIVES typically mistakes logical contraries (truth/lie, liberal/conservative, black/white, etc.) for logical contradictories (true/not true, liberal/not liberal, black/not black). *Contradictories* really do exhaust the possibilities. (A statement is either true or it's not true—what else could it be?) But *contraries*, while excluding each other (something can't be both true and a lie), do not exhaust all the possibilities (as, in this case, the possibility that the statement is neither true nor a lie, but just a plain old honest error). This FALLACY, for obvious reasons, is also sometimes called 'black/white thinking'.

A final point. Sometimes the FALLACY is committed in the context of asking a question which presupposes FALSE ALTERNATIVES. For example, someone might ask: Are you voting Republican or Democrat? Or: Are you for raising taxes or lowering them? This version of the error seems to be an instance of a FALLACY known as the FALLACY OF COMPLEX QUESTION. Most people will recognize this deceptive device in the lawyer's infamous question: 'When did you stop beating your wife?' The proper response to this courtroom ploy is to point out that the question presupposes that you have, either in the past or the present, beaten your wife. And that presupposition may be challenged. In the same way, the questions about voting and taxes presuppose that there are not other plausible alternatives—an assumption which may be challenged.

Begging the Question

The FALLACY OF BEGGING THE QUESTION is committed when the CONCLUSION to be established is simply assumed to be true in a PREMISS.

PREMISS: **Says that something is so (the very thing we are supposed to be proving).**

CONCLUSION: **Says (often in synonymous language) what the PREMISS says.**

Sometimes the reasoning directly assumes, as a PREMISS, the very point to be proved, though in slightly different language. Sometimes the FALLACY is less direct, and the QUESTION is BEGGED in what is some-

times called 'circular reasoning'. In each of these cases, the PREMISSES could be true only if we first grant that the CONCLUSION is true. Here's an example of the simpler error:

Women are not fit to be priests, because a priest's job is appropriate only for men.

In this reasoning, the reason given for the CONCLUSION is essentially the same point as the CONCLUSION itself.

(23) A priest's job is appropriate only for men.
↓ Women are not fit to be priests.

The controversial point to be proved is simply assumed in the PREMISS. As such, the PREMISS is unwarranted and the QUESTION (as to whether women are fit to be priests) is BEGGED.

Sometimes the QUESTION is BEGGED less directly.

Obviously there is a God. The Bible says so, and we may accept what the Bible says as true because, after all, the Bible is the word of God.

This reasoning is complex. The final CONCLUSION (that there is a God) is claimed to follow from the truth of the Bible, which, in turn, is claimed to follow from the fact that the Bible is the word of God:

(24) The Bible is the word of God.
↓ What the Bible says is true.
The Bible says there is a God.
↓ There is a God.

In this chain of reasoning, the first PREMISS begs the question at issue (Does God exist?). After all, if the existence of God needs proof, it will hardly do to say, as one of the PREMISSES, that the Bible is the word of *God.*

Inconsistency

The fallacy of inconsistency is committed when we reason from inconsistent PREMISSES, or we reason to a conclusion which is inconsistent with the PREMISSES. In other words either:

PREMISS: Says, or implies, that something both is and is not the case.

CONCLUSION: Could be anything.

or:

PREMISS: Says that something is the case.

CONCLUSION: Says, or implies, that same thing is not the case.

Inconsistencies or contradictions are bad news because once they are allowed, anything goes. For technical reasons which we can't go into in a book like this, it turns out that arguments with inconsistent PREMISSES are always VALID. But they are never COGENT because contradictory PREMISSES can't all be true. Here's a simple example:

I believe that the fetus is a person with an absolute right to life, and that abortion is, therefore, morally wrong, except in those tragic cases where the pregnancy is due to rape or incest.

In this example, the CONCLUSION that abortion is morally wrong is drawn from the assertion that the fetus is a person with rights:

(25) [I believe that] the fetus is a person with an absolute right to life.
↓ [I believe that] abortion is morally wrong, except in cases of rape and incest.

But if the fetus is truly "a person with an absolute right to life", then abortion ought not to be permitted even in cases of rape and incest. In other words, it is a contradiction to imply that the right can be abrogated in some cases. Such a 'right' surely would not be an 'absolute' right.

FALLACIES OF OMITTED EVIDENCE

FALLACIES arising from this error occur only with INDUCTIVE reasoning. Typically, the PREMISSES are true or warranted, but they fail to tell the full story. Rather, they omit, or intentionally suppress, information that has a direct bearing on the likelihood of the CONCLUSION in the sense that if the omitted information were added to the PREMISSES,

the VALIDITY of the ARGUMENT would be seriously weakened. I shall list several of the most commonly encountered FALLACIES OF OMITTED EVIDENCE.

Suppressed Evidence

We commit the FALLACY OF SUPPRESSED EVIDENCE when, in the course of INDUCTIVE reasoning, we omit or suppress information relevant to the CONCLUSION, in the sense that if the information were added to the PREMISSES, the CONCLUSION would be much less probable.

PREMISS:	**Says something that makes the CONCLUSION likely (but omits important information which makes the CONCLUSION unlikely).**
CONCLUSION:	**Follows validly from the stated PREMISS (but not with the addition of the omitted information).**

The FALLACY should be familiar to us already. For a good example, look back at ARGUMENT (32) in Chapter 1, about the Catholic priest.

Appeal to Inappropriate Authority

We commit the FALLACY OF APPEAL TO INAPPROPRIATE AUTHORITY when we claim that a statement or belief is true, and we give as our reason the fact that some person has said so, but (and this is important) the person cited as the authority has inadequate knowledge or is otherwise unreliable.

PREMISS:	**Says that person P accepts a statement S. (But P's knowledge or reliability is questionable.)**
CONCLUSION:	**Says that S is true.**

We have to rely on the testimony of experts for our beliefs about a great number of things that fall outside our personal experience, including our beliefs about history and science. Even when the experts are reliable, the best that an appeal to authority can do is make the conclusion *probable*. **No expert's say-so can guarantee the truth of a statement with deductive certainty**. But when the alleged

experts are not in a position to know, or are otherwise unreliable, the appeal to authority is inappropriate and a FALLACY is committed. Here's an example:

You wouldn't catch me living near a nuclear power plant. I saw an interview with Jane Fonda, and she said that nuclear power plants are very dangerous.

In this reasoning, the fact that Jane Fonda has said that nuclear power plants are dangerous is offered as evidence that nuclear power plants are dangerous. The ARGUMENT is essentially:

**(26) Jane Fonda says that nuclear power plants are dangerous.
↓ Nuclear power plants are dangerous.**

This is best taken as INDUCTIVE reasoning. But even so, the ARGUMENT is FALLACIOUS because Jane Fonda is not an appropriate authority. She may be an appropriate authority on the subjects of acting, Hollywood, and physical fitness. But not on nuclear power plants and their effects on human health. (Of course, the CONCLUSION may be true nonetheless.)

There are several reasons why an appeal to authority may be inappropriate: a) the authority may be outside his/her field of expertise. This is the problem with our Jane Fonda example; b) the authority may be biased and his/her objectivity may be compromised. Thus, if Professor Smith, an economist and expert on the U.S. defense budget, says that increased military spending would benefit the national economy, but it turns out that he is a highly paid lobbyist for the defense industry, the appeal to Professor Smith provides relatively weak support for the CONCLUSION that we should increase military spending. It would be a mistake, however, to conclude that what the professor says can be dismissed as false or unreasonable. (Indeed, to do so would be to commit a fallacy. Can you tell which one? If you can, no need to go back and look at the section on AD HOMINEM FALLACY.) Ultimately, what the professor says must be judged on the basis of the evidence he provides, not on his credentials; c) the authority may have a poor track record. Thus, if we assert that inflation will rise to 10 percent by the end of the year because Jones, an econo-

mist, says so, the strength of our appeal to authority would be undermined if it turned out that Jones had made dozens of economic forecasts in the past, few of which had been accurate; d) the authorities in the field are divided in their views of the matter, and there is no consensus of expert opinion. In such cases, the appeal to authority will provide no reason to believe one side rather than another, and ultimately, we must either attempt to evaluate the experts' arguments ourselves, or we must suspend judgment until a consensus among experts emerges.

Typically, in a FALLACY OF APPEAL TO INAPPROPRIATE AUTHORITY, one or more of these conditions a)–d) holds but is omitted in the formulation of the ARGUMENT. Because of this omission we treat this FALLACY as an instance of the general category—fallacies of omitted evidence. But it could also be classified as a FALLACY OF UNWARRANTED PREMISS, because all appeals to authority may be thought of as presupposing an unexpressed PREMISS to the effect that the authority is appropriate, or, in other words, that the conditions a)–d) don't apply.

Faulty Analogy

We commit the FALLACY OF FAULTY ANALOGY when we reason by analogy in ways that overlook or ignore important dissimilarities between the things being compared. In one version of reasoning by analogy, we compare two things, and we infer that because the two things are similar in having certain characteristics, and because one of the things has a certain characteristic, that therefore, the other thing probably has this characteristic also. The basic pattern of reasoning by analogy may be represented as follows:

A and B are similar in many ways.

A is known to have characteristic C
↓ B has C also.

For example, I might reason that since Ann and Barb have similar tastes in fashion, music, movies, books, and sports, and since Ann likes Rush Limbaugh, probably Barb does too. Of course, it could be that Barb does not like Rush. But the more similarities between Ann

and Barb, the more likely it is that a characteristic possessed by one will also be possessed by the other, all other things being equal.

Still, the dissimilarities are crucial. If Ann and Barb, for all their shared characteristics, fail to share similar political views (say, Ann is conservative, Barb is liberal), then the original inference from Ann's approval of Rush to the conclusion that Barb likes him too will be considerably weaker.

The lesson here is that in reasoning by analogy, it is extremely important for the COGENCY of the inference that the things being compared not be dissimilar in ways relevant to the occurrence of the characteristic being inferred in the CONCLUSION. (For example, dissimilarity of Ann and Barb's political orientation is relevant, but dissimilarity of their shoe size is not.) Otherwise we commit the FALLACY OF FAULTY ANALOGY:

PREMISS: Says that two things, A and B, are alike in certain ways, and that one thing, A, has a certain characteristic C. (But important dissimilarities between the two things are omitted.)

CONCLUSION: Says that the other thing, B, has C also.

In the following example Dad tries to convince young Jimmy, by means of analogy, that he (Jimmy) should ride his bike to school:

I don't see why you can't ride your bike to school, Jimmy. When I was a kid, that's what I did, and it was fine.

Dad's essential argument here makes an analogy between his (former) situation and Jimmy's:

(27) Dad was a kid who needed to get to school.
Jimmy is a kid who needs to get to school.
Dad successfully met his need by riding his bicycle to school.
↓ Jimmy should ride his bicycle to school.

This would be a good argument provided that Dad's situation and Jimmy's are not dissimilar in relevant ways. For example, if Dad was twelve years old when he rode his bike to a school which was less than one mile away on a lightly traveled rural road, but Jimmy is only

eight, and lives five miles from school on a busy highway, then the two situations would have relevant differences which would spoil the argument. In the argument made by Dad, these differences are ignored and so, the ARGUMENT commits the FALLACY OF FAULTY ANALOGY.

Of course, not all differences are relevant differences. If, for example, Jimmy objected to Dad's reasoning on the grounds that Dad's bicycle was a different color from his, or that Dad's school was public while his is private, Jimmy would not have had a legitimate criticism of Dad's analogy, because these differences are not relevant differences which would affect the strength of the original ARGUMENT.

A FAULTY ANALOGY will have a faulty comparison. But sometimes a FAULTY COMPARISON can, by itself, constitute a FALLACY, as when we reason that the rate of poverty in New Jersey is greater than in New Hampshire because New Jersey has more poor people than New Hampshire. The appropriate comparison in this case is between the percentage of poverty in the two states, not between the absolute numbers of poor people. Hence, the FALLACY OF FAULTY COMPARISON.

A FEW WORDS OF ADVICE FOR FALLACY HUNTERS

Before we turn to examine some of Rush Limbaugh's reasoning, we should remember that identifying, analyzing, and appraising everyday ARGUMENTS is as much an art as it is a science. Ordinary, everyday language is vague and ambiguous, and the subtleties of the conversational context only compound the complexity of the analyst's task. Often even the people whose ARGUMENTS we are analyzing are not in a position to tell us what exactly their intentions were. This means that any attempt to analyze and appraise ordinary ARGUMENTS will be subject to a certain amount of interpretation. As we have already seen in some of our earlier examples, the attempt to identify the reasoning may give rise to alternative variations, all of which can (and should) be true to the original intent so far as that can be determined.

There are a few rules of thumb here. But it is important to remember that the identification of ARGUMENTS, their analysis, and their appraisal is not a rigorous science. Rather, it is complex and inherently imprecise undertaking, and one about which reasonable people can differ.

1. <u>Be charitable to the arguer.</u> Don't make the arguer out to be a complete fool if you can help it. When there are equally plausible ways to interpret an argument, the PRINCIPLE OF CHARITY requires that we opt for the interpretation that makes the stronger ARGUMENT. When the arguer has said something that seems ridiculous, look to see if there is a less ridiculous but plausible meaning.

2. <u>Be faithful to the arguer's intended meaning</u> when analyzing an ARGUMENT. The PRINCIPLE OF FIDELITY requires that we not interpret an arguer's sentences in unfair ways that violate the arguer's intentions, to the extent that those can be determined.

3. <u>Determine what is the point at issue,</u> which the passage under consideration is trying to prove or convince us of. This will be the CONCLUSION. (If it's not trying to prove anything, it's not an ARGUMENT. But remember, the CONCLUSION may be implied and not explicitly stated.)

4. <u>Look for ARGUMENT INDICATORS</u> (like 'therefore' and 'because') to help you find the CONCLUSION and the PREMISSES and to distinguish one from the other. (Remember, PREMISSES may be unexpressed. This often happens when they are too obvious to state.)

5. <u>Look to see if the PREMISSES really support the conclusion.</u> If not, there is a FALLACY OF INVALIDITY.

6. <u>Look to see if the PREMISSES are true or warranted.</u> If not, there is a FALLACY OF UNWARRANTED PREMISS.

7. <u>Look to see if the PREMISSES omit any facts which, if included, would weaken the ARGUMENT.</u> If so, there is a FALLACY OF OMITTED EVIDENCE.

ANALYZING AND EVALUATING ARGUMENTS: A REMINDER AND AN EXAMPLE

As we have seen, analyzing and evaluating a piece of reasoning usually requires that we first recast the ARGUMENT to reveal its structure

(PREMISSES and CONCLUSION) more clearly. Because language is some-
times vague or ambiguous, and because arguers sometimes fail to
state facts that are assumed or implied, recasting ARGUMENTS is sub-
ject to a degree of interpretation. This means that often there will be
more than one way to recast an ARGUMENT. It's obviously important in
this task to be charitable to the arguer and not unfair to his/her inten-
tions, as best those intentions can be determined. The following ex-
ample is adapted from remarks of a non-dittohead overheard by the
author.

> **How can you believe that 'bull' Rush Limbaugh spreads about
> liberals? As his biographer makes quite clear, Limbaugh is an
> insecure guy who is still trying to live up to his deceased father's
> conservative values and critical demands that he amount to
> something more than a college dropout who had to spin records
> for a living.**

Even though there aren't any ARGUMENT INDICATORS to guide us,
it's pretty clear what the arguer's intentions are. The initial question
is rhetorical and meant to assert that Rush's criticisms of liberals are
false or otherwise unworthy of belief. The reason given as support
for this CONCLUSION is Rush's family background and its alleged influ-
ence on his thinking. The main reasoning could be represented as:

**(28) Rush's criticism of liberals is a (subconscious) attempt to
live up to his father's expectations.
↓ Rush's criticism of liberals is false (untrue).**

When the ARGUMENT IS recast this way, we seem to have a FALLACY
OF INVALIDITY. It's a NON SEQUITUR that looks much like our old friend
ARGUMENTUM AD HOMINEM, the main feature of which is an irrelevant,
or largely irrelevant, attack on the person (in this case, the person's
motives) instead of a direct examination of the views in question
(Rush's criticisms of liberals). A variation of the AD HOMINEM which
attempts to dismiss an idea because of its origin is sometimes called
the GENETIC FALLACY. And a version of that FALLACY which attempts to
dismiss an idea because of the psychological origin of the motivation
for the idea is known as the PSYCHOANALYTIC FALLACY (I realize that

our list of FALLACIES has grown quite large, and that some dittoheads may be having trouble keeping them all straight, but this is a book about FALLACIES, remember. Don't forget that there are only three general kinds).

Of course, if the PREMISS is true, we might be *suspicious* of Rush's criticisms, but we can't, for this reason alone, dismiss them as untrue. The CONCLUSION simply does not follow. There's a logical gap, we might say, between the PREMISS and the CONCLUSION.

However, if we assume that all or most criticisms of liberals that arise from such motivation based on unconscious conservative paternal influence are false, then we could close the gap between PREMISS and CONCLUSION. Perhaps the author had some such (unexpressed) PREMISS in mind. If so, we could have:

(29) Rush's criticisms of liberals are a (subconscious) attempt to live up to his father's expectations.
All or most criticisms from such motivation are false.
(Unexpressed PREMISS)
↓ Rush's criticisms are false.

Now the original reasoning, recast as (29), is valid. But a new problem arises: the unexpressed PREMISS is very doubtful. How, after all, could we hope to establish such a claim with any degree of confidence? It seems we couldn't, and for this reason (29) seems to be a FALLACY OF QUESTIONABLE PREMISS.

Indeed, the first PREMISS of (29) also seems doubtful, at least the evidence provided in the original reasoning is less than convincing. That evidence is no more than a biographer's say-so. We haven't bothered to mention this weakness because even if this PREMISS were warranted, it is mainly irrelevant (that's to say, without the unexpressed QUESTIONABLE PREMISS) to the truth of the CONCLUSION. But the weak support offered for the first PREMISS illustrates an interesting logical point and yet another FALLACY. Here's the essential ARGUMENT (implicitly) offered:

(30) A biographer of Rush Limbaugh says that Rush is insecure and feels a (subconscious) need to live up to his father's expectations by criticizing liberals.
↓ It is so. (Implied)

The ARGUMENT should be taken as INDUCTIVE. But even so, there is a good chance that we have the FALLACY OF APPEAL TO INAPPROPRIATE AUTHORITY. The biographer may not be a qualified expert in the field of psychology. And, he may have a political axe to grind. These possibilities, if true, would not show that the CONCLUSION of (30) is false, but would weaken the argument's claim to COGENCY.

In the chapters that follow we will examine Rush Limbaugh's reasoning on a number of topics selected from his two recent best sellers, *The Way Things Ought To Be* and *See, I Told You So*. In each selection we will try to determine just what is going on in the passage, how best to represent the essential ARGUMENTS and how best to evaluate them in terms of our rules of thumb, including our PRINCIPLES OF CHARITY AND FIDELITY.

In choosing Rush's books as the source of my examples rather than, say, his radio programs, I focus on Rush's most considered views, statements he has put down in black and white only after serious deliberation. Writers of books have the opportunity to show drafts round to friends, check opinions they may be unsure of, and otherwise to revise their work carefully. By contrast, remarks made on-air are necessarily prone to occasional carelessness and omission due to the extemporaneous or ad lib nature of the medium. To have culled my examples from that source would have been less than fair.

A few selections may prove difficult for one or two dittoheads. Accordingly, I have clearly marked these items and issued warning so that cautious dittoheads may avoid injury from overload of their cerebral processes.

Rush and the Environmentalists

Whacking the Wackos

Rush's ruminations on the environment reveal two of his fundamental beliefs: 1. that environmentalism is a threat to the country's economic well-being, and 2. that the environmental movement is controlled by liberals who play on people's fears to gain political power and control. Both themes lie not very far below the surface of much of Rush's reasoning about the environment and its advocates. Rush doesn't argue for these beliefs directly, rather he prefers to persuade his audience that most environmentalists are wackos whose claims about civilization's threat to the environment are exaggerated and ill-founded.

A Bruise for Cruise

In our first example, Rush takes aim at the environmental movement and Tom Cruise in particular.

> There were 750,000 people in New York's Central Park recently for Earth Day. They were . . . listening to Tom Cruise talk about how we have to recycle everything and stop corporations from polluting. Excuse me. Didn't Tom Cruise make a stock-car movie in which he destroyed thirty-five cars, burned thousands of gallons of gasoline, and wasted dozens of tires? If I were given the opportunity, I'd say to Tom Cruise, 'Tom, most people don't own thirty-five cars in their life, and you just trashed thirty-five cars for a movie. Now you're telling other people not to pollute the planet? Shut up, sir.'
> (*The Way Things Ought To Be*, p. 158)

In this passage, no doubt meant to be humorous, Rush attacks Tom Cruise for not practicing what he preaches. Whatever else Rush intends here he certainly intends to imply that because of Cruise's apparent inconsistency (between his words and his deeds), he is a hypocrite. The reasoning looks like this:

(1) Tom Cruise says we have to recycle everything and stop corporations from polluting.
But Tom Cruise made a movie in which he destroyed thirty-five cars.
↓ He is a hypocrite. (Implied)

ARGUMENT (1) seems OK. (Score one for Rush.) We could raise the question of whether Cruise's actions are typical of his behavior, or whether this example of resource wastefulness may be an uncharacteristic deviation in an otherwise conservation-minded lifestyle. But

let's grant the cogency of the argument—let's grant that the CONCLU-SION is adequately supported by warranted PREMISSES.

But there seems to be more going on in the original passage than merely calling attention to Cruise's hypocrisy. There seems to be the added implication that Cruise (as hypocrite) has no right to say what our environmental policy ought to be, and therefore that his message may justifiably be ignored. We can represent the reasoning as a complex of two arguments.

(2) Tom Cruise is a hypocrite.
 ↓ He has no right to say what ought to be done about pollution. (Implied)
 ↓ We can justifiably ignore his recommendations. (Implied)

Both arguments in (2) have problems. Take the first argument. Do people who fail to adopt their own recommendations forfeit their right to make such recommendations? Hardly. Of course it's true that they are usually less effective in getting others to adopt their recommendations. Other people figure that if they don't follow their own advice, probably they don't believe that it's good advice; and if the advice-giver doesn't think it's good advice, why should they?

But on the question of environmental policy, nobody has to depend on Cruise's word to know whether his advice is good or not. There are independent ways to assess his claims and recommendations. In short, whether Cruise believes his own advice or not is irrelevant to the real questions at hand: *Is his assessment of the environmental situation accurate?* and *Are his recommendations good?*

So, even if we grant that somehow Cruise forfeits his right to preach on the pollution issue, his message may still be correct and important. And if it is, it ought be heeded and not dismissed—not because Cruise says so, but because of the nature of the *message.*

Rush's original passage, then, is yet another example of the AD HOMINEM FALLACY. That is, he attacks Cruise and his alleged hypocrisy as a way of undermining Cruise's message about pollution. What makes the attack a FALLACY is not that it is directed against the person, but that it is an attack which is irrelevant to the truth or falsehood of Cruise's message (see my explanation of the AD HOMINEM FALLACY in Chapter 2, page 30).

It goes without saying, of course, that this sort of error is not unique to Rush Limbaugh. As we saw in Chapter 2, liberals, no less than conservatives, have a penchant for the AD HOMINEM ARGUMENT. Indeed, it is a mistake that is very widespread, on all sides, in policy discussion in the media as well as in the arena of American politics.

A final comment about this passage. Some dittohead might object that it's unfair to say that Rush is trying to discredit Cruise's message; that he merely wants to make the ARGUMENT that Cruise is a hypocrite (an unusually subtle point for a dittohead). I think this is a possibility, but just a bare possibility. If we do grant this unduly charitable interpretation of the passage in question, it will allow Rush to escape the charge of AD HOMINEM FALLACY. But it will do so at the cost of opening Rush to the charge of EVADING THE ISSUE (see Chapter 2, page 33) which, after all, is not Tom Cruise and what to do about him, but the environment and what to do about pollution.

Goring Gore

Environmentalism is one of Rush's favorite targets. Here he is trying to debunk what he calls the "environmentalist wackos", especially Vice President Al Gore.

> He [Gore] claims that agriculture in America is threatened because of topsoil erosion. Yet, according to the Soil Conservation Service, thanks to technological breakthrough, fewer acres have been suffering severe erosion in the US.
> *(See, I Told You So*, p. 163)

The reasoning here seems straightforward enough. Rush is citing the Soil Conservation Service to show that Al Gore is wrong about topsoil erosion in America. We can represent the argument as:

(1) Gore claims that American agriculture is threatened by topsoil erosion.
But the Soil Conservation Service says that fewer US acres have been suffering severe erosion.
↓ Gore is wrong.

First of all, the language of the second PREMISS is somewhat vague, and it's hard to know what exactly it is supposed to mean. Should it be taken to allow that *moderate* erosion is on the rise? But even if it means that the rate of topsoil loss is less today than it was (say) ten years ago, it still does not follow that there is no threat to agriculture. One could as well argue that since there are fewer deaths from heart disease today than there were ten years ago, that therefore heart disease poses no problem for human health. So Rush's argument is INVALID; its CONCLUSION does not, strictly speaking, follow from the PREMISSES, even if those PREMISSES are true; it is a NON SEQUITUR.

But there is something else going on here as well. If we go back to the source of Gore's alleged claim (his book, *Earth in the Balance*),

we will find that he does not make any such claim. What he says in one short paragraph is that "The Mississippi River carries away millions of tons of topsoil from farms in the middle of America", and that Iowa, which "used to have an average of sixteen inches of the best topsoil in the world . . . now is down to eight inches."

These statistics are, let us suppose, accurate. Rush does not question them. But Gore mentions this in the context of his own interest in environmental protection, which he says began with lessons on soil erosion back on his family farm. His point is merely that soil erosion, like many aspects of environmental decline, continues often because of short-term profits and an unwillingness of people to face up to the long-term consequences of their practices. There is, I think, the unstated implication that this on-going drain of a vital resource could, if allowed to continue indefinitely, hurt American agriculture. But this implication is surely compatible with the Soil Conservation Service's statement that erosion isn't as severe as it used to be.

Rush has put his own spin on Gore's statement to give the misleading impression that Gore was claiming a crisis in soil erosion. This makes Rush's argument also a STRAW MAN FALLACY, an intentional mischaracterization of an opponent's position for the purpose of making that position easier to refute (see Chapter 2, page 39).

More Gore

Here's Rush attacking Al Gore's critique of US environmental policies.

> There is something intrinsically anti-American about the way [Gore] flagellates the US over its environmental policies. He writes that cultures are like families and "our civilization must be considered in some way dysfunctional [because of its brutal assault on nature] . . . " This from a guy who gets lost hiking in a park with the Secret Service!
>
> (*See, I Told You So*, pp. 163–64)

There is Limbaugh levity here. But let's not lose sight of the logical thrust of the passage. Rush is using Gore's apparent ineptitude in the woods as a means of discrediting Gore's view about our civilization being dysfunctional. The argument may be represented as:

(1) Gore says that our civilization must be considered dysfunctional in its treatment of the environment.
But Gore got lost hiking in a park.
↓ We can dismiss his view that our civilization is dysfunctional.
(Implied)

This argument is pretty clearly AD HOMINEM (see Chapter 2, page 30). The attack on Gore, even if true, is irrelevant to the main point at issue: Is our civilization dysfunctional?

(Note well, dittoheads: that the AD HOMINEM FALLACY is not simply a personal attack, as Rush seems to think [*See, I Told You So*, p. 42]. It is an attack which, even if true, is irrelevant to the point at issue. If I argue that Smith is dishonest because he cheats on his income tax, there is a personal attack but no AD HOMINEM FALLACY. But if I try to discredit Smith's ideas about, say, reducing the deficit because he cheats on his income tax, I commit the AD HOMINEM FALLACY.)

The above passage also seems to contain a line of reasoning to the effect that Gore's view that civilization is dysfunctional shows that he is anti-American. Although Gore does not specifically mention the US, Rush apparently takes his indictment of civilization to include US environmental policies. This may well have been Gore's intent, but even so it would hardly make Gore "intrinsically anti-American". And even if it did, it's not relevant to the main point at issue which is not Gore, but the cogency of *Gore's ideas and* ARGUMENTS.

Gore and Taxes

Here's another kind of attack directed at the Vice President's economic ideas for dealing with some aspects of our environmental problems.

> Algore [Al Gore] would hand out "tax incentives for new technologies and disincentives for old. Research and development funding for the new technologies and prospective bans for the old ones." (Pardon me, but I didn't think he believed in tax incentive and disincentives. Only trickle-down supply-siders believe that tax policy affects people's economic behavior.)
>
> And this is the book that President Clinton called a masterpiece.
>
> (*See, I Told You So*, p. 165)

One way to look at this passage is to view it as an indirect attempt to discredit Gore's economic proposals by pointing out that the proposals are inconsistent with his previous criticism of supply-side economics. From this perspective, the reasoning would be a complex of two ARGUMENTS with implied CONCLUSIONS:

(1) Al Gore proposes tax incentives to help develop
environmentally sound technologies.
But these policies are at odds with his criticism of
supply-side economics.
↓ Gore is inconsistent. (Implied)
↓ We should dismiss or ignore his proposal. (Implied)

Viewed in this way, Rush's second ARGUMENT is AD HOMINEM. The fact that Gore's present proposal is inconsistent with his previously stated position, if it is a fact, does not afford a good reason for dismissing or ignoring his present proposal. His proposal might contain

good ideas even if it does deviate from his previously expressed views on economics.

But is Gore's proposal inconsistent with his earlier criticism of supply-side economics? Hardly. Liberals like Gore, who have criticized supply-side economics, did not object to all the features of the policy, only to some. On the matter of tax incentives associated with supply-side economics (for example, during the Reagan years), Gore's objection, like that of most liberals, was not against tax incentives *per se,* but against their *overuse* which, many liberals claim, worked to the benefit of a privileged few. What Rush has done is to mischaracterize Gore's position in order to support the charge of inconsistency. This is the STRAW MAN FALLACY (see Chapter 2, page 39).

It is arguable that Rush is not intending to imply that Gore's ideas are flawed or unworthy of attention. On this interpretation, the original passage would be correctly represented only by the first ARGUMENT in (1). This is a possible defense of Rush, but not very convincing. That Rush does intend to discredit Gore's proposal is strongly suggested by his final remark implying that it is Gore's book, not just Gore, that is flawed. But even if Rush were merely making an ARGUMENT about Gore (that he is inconsistent), he would be open to the charge of EVADING THE ISSUE, namely, whether Gore's proposal has merit.

Gore's Gas-guzzler*

Here's yet another AD HOMINEM directed at Al Gore.

> You would think that if Algore and company believe
> so passionately in their environmental crusading
> that [sic] they would first put these ideas to work in
> their own lives, right? . . . Algore thinks the automo-
> bile is one of the greatest threats to the planet, but
> he sure as heck still travels in one of them—a gas
> guzzler too.
>
> (*See, I Told You So*, p. 168)

In this passage Rush implies that since Gore doesn't practice what he preaches, he may not really believe what he says about the car being a threat to the planet. And, though this is more doubtful, there may be the further suggestion that since Gore doesn't really believe it, we shouldn't either. Let's look at the first, less doubtful, argument first:

(1) If Gore really believed that the automobile was a threat to the planet, he wouldn't drive a gas-guzzler.
 But he does drive one.
 ↓ He does not really believe that the automobile is a threat. (Implied)

ARGUMENT (1) is VALID. It has a VALID form known as MODUS TOL-LENS (more Latin folks, sorry about that. Don't worry about what it means, just don't confuse it with the INVALID form of DENYING THE ANTECEDENT illustrated in Chapter 2, page 26. The MODUS TOLLENS form looks like this:

*Warning: This selection has been tested and found to cause BSS (brain strain syndrome) in some dittoheads. Cautious dittoheads are hereby permitted to skip this item in favor of a less challenging one.

A Crush on Gore

(2) If p, then q
Not-q
↓ Not-p

This form guarantees the VALIDITY of any ARGUMENT, including (1), that can result from putting any statements in place of 'p' and 'q'. In other words, any ARGUMENT having this form, including (1), will provide complete support for the CONCLUSION, that is to say, it will be DEDUCTIVELY VALID, or, to put it yet another way, the CONCLUSION must be true if the PREMISSES are true. So the CONCLUSION of (1) is true if the PREMISSES are true. Are they? It's very doubtful.

I haven't the foggiest idea whether Gore really drove a gas-guzzler at the time in question. If he didn't, that fact would spoil the COGENCY of Rush's ARGUMENT. But let's assume that he did. What about the other PREMISS?

There's an old adage that we ought to practice what we preach, that Rush is no doubt appealing to here. I'd say he's right. (Dittoheads need not applaud here; everybody's right once in a while.) It generally makes good sense, for obvious reasons. One of the problems of not practicing what we preach is that people may get the idea that we don't really care about, or believe, what we're preaching, and as a result we may lose converts and even supporters (just ask Jimmy Swaggart).

But it also seems unwarranted to say generally that if people don't practice what they preach they don't really believe what they preach. People, even preachers, sometimes do things they themselves know to be wrong and harmful and contrary to their own best advice.

In Gore's case we can only speculate. But surely we know enough about human nature in general not to take Gore's alleged transgression as good evidence that he doesn't believe his own message.

There is an interesting point of logic that may help explain Rush's error here. It is just possible that Rush is confusing two different ways of talking about 'the automobile'. If I say, looking in Al Gore's driveway, 'The car is a gas-guzzler', I am speaking about an *individual* automobile. But if, after reading Al Gore's *Earth in the Balance*, I say 'The car is a serious threat to the planet', I'm speaking about cars in a collective sense. Now it's not Al Gore's individual car that's the threat

to the planet; it's cars collectively. If one were to ignore this distinction, one might think that if the car were really a serious threat to the planet, then anyone who had a car would be seriously threatening the planet. Presumably no rational person would knowingly threaten the planet. So, from this (confused) point of view, it's only reasonable to conclude that the car-user who espouses the theory in question does not really believe what he/she says.

The fallacy based on this kind of confusion is the FALLACY OF DIVISION. Automobiles considered collectively are to be distinguished from automobiles considered individually: what is true of cars considered collectively (being a threat to the planet) is not necessarily true of cars considered individually. Rush may be committing this FALLACY. If he is, that fact helps us to understand the FALLACY he definitely does commit in argument (1), namely, QUESTIONABLE PREMISS.

Finally, we said that Rush may be trying to discredit Gore's theory about the automobile and planetary well-being. Rush doesn't actually say that the theory is false. But by discrediting Gore (he doesn't practice what he preaches, he doesn't even believe what he preaches) he may be hoping that the reader will draw the inference that Gore's theory is unworthy of serious attention. If he is, the argument could be represented as:

(3) Gore doesn't practice what he preaches, and he doesn't believe what he preaches.
↓ Gore's theory is unworthy of attention.

The CONCLUSION doesn't follow; indeed, the PREMISSES, even if true, are strictly irrelevant to the question of the truth of Gore's claims. What we have in (3) is a familiar pattern in many of Rush's ARGUMENTS—the AD HOMINEM FALLACY. If we are going to dismiss or ignore Gore's theory, we had better base that decision on the merits or demerits of the theory itself and not on the alleged moral shortcomings of the theorist.

If Rush is not suggesting the reasoning represented by (3), then he is not, in the original passage, committing the AD HOMINEM FALLACY. However, an issue at least as important as Gore's character is the truth or falsehood of his claim about the dangers of the automo-

bile. The fact that Rush ignores that issue in the passage—and in the rest of his discussion of the environment—leaves him open to the charge of EVADING THE ISSUE (see Chapter 2, page 33).

The Cosmic Hoax

Here's Rush exposing what he claims to be one of "the biggest environmental frauds perpetuated [sic; he means perpetrated] on us"—ozone depletion.

> Has anything man has ever done even approximated the radiation and explosive force of a supernova [which Rush says occurred 340,000 years ago and "disrupted" 10 to 20 percent of the ozone layer]? And if prehistoric man merely got a sunburn, how is it that we are going to destroy the ozone layer with our air conditioners and underarm deodorants and cause everybody to get cancer? Obviously, we're not . . . and we can't . . . and it's a hoax.
>
> (*See, I Told You So*, p. 178)

The reasoning here is apparently intended to support his claim that it's a hoax that the ozone layer is being destroyed. He first reasons that human-made chemicals can't hurt the ozone because they are much less powerful than the supernova which caused little harmful damage to the ozone and humans. The reasoning can be shown as a complex of two ARGUMENTS:

(1) **A supernova 340,000 years ago caused disruption to the ozone but little harm to humans.**
The force of what man has done is tiny compared with that of a supernova.
↓ **The addition of human-made chemicals (such as aerosols, CFCs) to the atmosphere can't result in increased skin cancer from ozone depletion.**
↓ **The claim (that human-made chemicals are causing cancer through ozone depletion) is a hoax.**

To know whether these ARGUMENTS are any good, we have to know a little science in addition to logic. (I said "a little" science. Logicians, no less than talk show hosts, run the risk of making fools of themselves if they try to talk like experts here.) It is generally agreed within the global scientific community that ozone depletion is taking place. Hard evidence establishing the connection between ozone depletion and increased ultraviolet radiation is available (see *Science News*, July 3rd, 1993). What is unclear, however, is how much ozone depletion is due to human factors (such as CFC in air conditioning systems) and how much to natural factors (such as volcanic eruptions). Recent findings by NASA identify human-made chemicals (CFCs), not natural sources, as responsible for the ozone hole over Anarctica (see *Science News*, December 24th and 31st, 1994).

Rush has two ARGUMENTS. Both are NON SEQUITURS. I have no wish to dispute what he says about a supernova several hundred thousand years ago, but his first CONCLUSION does not follow, because even if human impact on the ozone layer is small compared with earlier natural events, that small impact could still be sufficient to trigger an acceleration of feedback systems capable of causing the earth's ecological balance to spiral out of control.

To use an analogy: one might argue that a small earth tremor of 3 or 4 on the Richter scale could hardly cause the collapse of a building that had withstood a quake of 7. The point is that the big quake may have severely weakened the structural integrity of the building so that even a small additional vibration would bring it down.

His second CONCLUSION does not follow because a hoax involves deception, that is to say, an intention to mislead. So even if the scientific claims about human-made chemicals and ozone depletion should prove false, that wouldn't prove that the claims were a *hoax*.

Rushing the Liberal Frauds

Here's Rush once again on the ozone controversy and liberal bad faith.

> . . . here's what <u>The Washington Post</u> said in an editorial on February 5, 1992: "Once again, it turns out that the protective ozone layer is being destroyed faster than even the pessimists had expected."
>
> Then, on April 15, 1993, a front-page story had this to say: ". . . researchers say the problem appears to be heading towards solution before they can find any solid evidence that serious harm was or is being done." . . . But have you heard Algore [Al Gore] or any other ozone alarmist step up and admit that he or she perpetuated [sic] a fraud on the American people?
>
> (*See, I Told You So*, p. 179)

Rush argues that because 1993 press reports conflict with earlier alarmist reports, Gore and others were wrong on ozone depletion, and therefore, he and others perpetrated a fraud on the American people. This reasoning is a complex of two arguments:

(1) **In 1992 the liberals said ozone depletion was worse than even pessimists had believed.**
But in 1993 they said the problem, not yet proved harmful, was heading towards a solution.
↓ Gore (and other liberals) were wrong about ozone depletion. (Implied)
↓ Gore (and other liberals) perpetrated a fraud on the American people.

Rush's second ARGUMENT is a NON SEQUITUR, and his first ARGUMENT may be as well. The potential difficulty with his first ARGUMENT becomes apparent when we consider the second paragraph (omitted by Rush) of the 1993 *Washington Post* story (Yes, logicians as well as conservatives sometimes have to read the liberal press): "As a result of the Montreal Protocol, an international treaty obliging signatory countries to phase out ozone-destroying chemicals, scientists expect the threat of ozone destruction to peak in just seven years." (This article, written by Boyce Rensberger, a respected science writer at *The Washington Post*, received the American Association of the Advancement of Science-Westinghouse Science Journalism Award in 1994.)

So, according to Rush's own source of information, the ozone problem is under control, not because there was no problem, but at least partly because 'environmentalist wackos' organized an international treaty to stop it. The implication of Rensberger's article is two-fold: a) that the ozone depletion problem was serious enough to warrant an international treaty restricting use of ozone-depleting substances, and b) that the problem is being brought under control "as a result of" the treaty.

So were Gore and other liberals wrong about the ozone problem? That depends, of course, on what exactly they said about it. What seems undeniable is that some scientists exaggerated the problem, gave undue weight to preliminary evidence and, as a result, needlessly scared a lot of people. If Gore bought into these exaggerations (some of his anecdotes about animals in Patagonia allegedly blinded by increased ultraviolet radiation have a distinctly alarmist tone), he was, in a sense, wrong about the ozone problem. (The alarmists might say, with some justification, that when it comes to matters with the potential for global disruption of the ecosystem, it's better to overstate the risks than to understate them.) But, that there was and is a problem in need of international controls also seems undeniable. This point, as we saw above, is clearly implied by the evidence that Rush omits. So, if we decide that Gore was not wrong on ozone depletion, Rush's first ARGUMENT is a NON SEQUITUR owing to OMITTED EVIDENCE (see Chapter 2, pages 24 and 43).

Rush's second NON SEQUITUR is similar to the error we saw in the previous example. A fraud, like a hoax, involves the intention to mislead. The mere fact that one's theory is *wrong* does not show that it is a *fraud*.

A final note about the ozone controversy. In a follow-up to his *Washington Post* piece, Rensberger comments in the *Skeptical Inquirer*, Fall 1994, p. 497, on the widespread criticism that his article received in environmentalist circles. He states:

> **I suspect that people had become so used to alarmist stories on ozone depletion that my neutral story appeared, by contrast, to be unduly optimistic. Some people even came away with the impression that I had claimed that the ozone depletion problem was a hoax. . . . [T]here were some people making the hoax claim—Rush Limbaugh, the late Dixie Lee Ray [former governor of Washington], and some disciples of Lyndon La Rouche. . . . For the most part, these people are way off base.**

Let Them Eat Environmental Scientists

Here's Rush attacking Paul Ehrlich, a prominent environmental scientist and author of *The Population Explosion.*

> [Paul Ehrlich says that] the way to save humanity from pollution and death is to force mankind to live in abject poverty. . . . he writes, "Poor people don't use much energy. . . the average Bangladeshi is not surrounded by plastic gadgets . . . the average Chinese does not have air conditioning or central heating in his apartment." Mind you, none of these notions has persuaded Ehrlich himself to move to Bangladesh . . . or China. . . . By all accounts, he lives quite comfortably in a very large air-conditioned house in the US.
>
> (*See, I Told You So*, p. 182)

The main bit of reasoning going on here is an attempt to discredit Ehrlich's (alleged) recommendation for saving humanity by pointing out that Ehrlich doesn't live an impoverished lifestyle and implying that he is a hypocrite. The pattern, a favorite of Rush's, may be represented as:

(1) Paul Ehrlich says that to save humanity mankind should be forced to live in abject poverty.
But Ehrlich himself has a high standard of living in the US.
↓ Ehrlich is a hypocrite. (Implied)
↓ His views may be ignored, dismissed, etc. (Implied)

This is vintage Limbaugh. Once again we encounter the AD HOMINEM ARGUMENT. Of course, the issue is not whether Paul Ehrlich is a

hypocrite or not. It's whether his views are worthy of acceptance. Even if Rush's characterization of Ehrlich's views were accurate, Rush's attack is clearly irrelevant.

But what about the first PREMISS of (1)? Is that an accurate statement of Ehrlich's views? Hardly. It seems that Rush has created a fictitious opponent here. The fact that Rush has unfairly characterized Ehrlich's views makes ARGUMENT (1) an instance of the STRAW MAN FALLACY. We should recall that this FALLACY occurs anytime we mischaracterize our opponent's position in order to more effectively refute it. (See Chapter 2, page 39.)

Rush may realize that his characterization of Ehrlich looks suspicious, and that may account for Rush's attempt to support his characterization by quoting from Ehrlich's book as cited in the original passage above. Rush's reasoning looks like this:

(2) Ehrlich writes "Poor people don't use much energy. . . ."
↓ Ehrlich says people should be forced to live in abject poverty to save humanity.

There is a serious problem with this ARGUMENT. It's a NON SEQUITUR; the CONCLUSION simply doesn't follow from the PREMISS. If Ehrlich is recommending anything in the passage cited, it may be merely that we should use less energy.

The Baby Haters

Here's another bit of reasoning directed again at Paul Ehrlich:

> [According to Ehrlich]: "Based upon per-capita commercial energy use, a baby born in the US represents twice the disaster for Earth as one born in Sweden or the USSR, . . . thirty-five times one in Chad, Rwanda, Haiti, or Nepal." . . . Note his phraseology: Babies, the epitome of innocence . . . represent disaster. And they tell us they are for family values.
>
> (*See, I Told You So*, p. 183)

In this passage Rush is taking Ehrlich's statement that American babies have a greater environmental impact than those in poor countries as evidence that his values are anti-family. The reasoning may be represented as:

(1) Ehrlich says that an American baby has a much greater environmental impact than those of other countries.
↓ Ehrlich and his liberal supporters are against family values.

This ARGUMENT is a good old-fashioned NON SEQUITUR; the CONCLUSION just doesn't follow from the PREMISS. After all, one can be mindful of the relatively greater environmental impact of American children (and even advocate smaller families) without being against 'family values' in the ordinary meaning of that term.

Rush and Multiculturalism

What's So Great About Dead White Guys?

Rush doesn't like the multicultural movement. His main concern seems to be that this movement is unduly anti-American and will undermine our country's spirit of nationalism. This is not an unreasonable concern. But as we attempt to assess the cultural diversity movement we must exercise special care not to allow our normal nationalistic biases to adversely affect the quality of our reasoning. Unfortunately, for whatever reasons, Rush's ARGUMENTS on this issue often leave much to be desired—especially COGENCY.

Rushing Stanford

In our first example, Rush intends to defend Western culture against some of its critics.

> I'm sick and tired of people trying to change history so as to portray this country as an instrument of evil. It isn't true. I'm sick and tired of hearing Western culture constantly disparaged. "Hey, hey, ho, ho, Western culture's got to go," is the chant at Stanford University. What would Stanford be if the pioneers that are so reviled today as imperialists, racists, sexists, bigots, and homophobes hadn't fought their way across a continent to California?
>
> (*The Way Things Ought to Be*, p. 45)

Let's try to understand what's going on in this passage. Rush is presumably doing more than simply railing against the critics of Western culture. And he is surely trying to do more than merely state a bit of psychological autobiography ("I'm sick and tired . . . "). Indeed, he says that their version of history according to which the U.S. is an "instrument of evil" just "isn't true." And it's reasonable to take him as trying to provide reasons why we should dismiss these tiresome criticisms of Western culture.

Indeed, the point at issue that emerges from this passage is the question of the truth of the critics' charges, and Rush is required by the context of the passage to address this issue. To the extent that he fails to address the issue, or addresses an irrelevant issue, he is guilty of FALLACY.

What he actually does, however, is to make an attack on a particular group of critics at Stanford (who may or may not be typical of those who criticize Western culture and call for change). But he attacks them by pointing out (quite correctly) that Stanford probably would not even exist had it not been for the pioneers and others, so reviled by the Stanford critics.

78

It's difficult to be sure exactly what Rush intends as his CONCLU-SION. He would no doubt like this audience to think that he has somehow disproved the accuracy of the critics' charges. So he may intend to imply that the criticisms are false. Here's how that ARGUMENT would look:

(1) People at Stanford criticize Western culture.
But Stanford wouldn't be here if not for the cultural heroes that the critics revile.
↓ The criticism of Western culture at Stanford can be dismissed as false, ridiculous, etc. (Implied)

If this is what Rush is up to in the above passage, he's committing a FALLACY OF INVALIDITY (see Chapter 2, page 24). His reasoning is a NON SEQUITUR (from the Latin, meaning 'it does not follow'); the CONCLUSION does not follow from the PREMISSES. In this FALLACY the PREMISSES provide little or no support for the intended CONCLUSION (though they may be relevant to some other CONCLUSION which is not at issue).

Rush may be correct in his description of what (some? most?) people at Stanford have criticized about Western culture. He may even be correct in what he implies about the role of these disparaged pioneers in the creation of Stanford. Unfortunately, these things have little if any bearing on the issue at hand: whether there is any merit in the Stanford criticisms of Western culture.

As the ARGUMENT has been interpreted, it is a fairly typical example of the form of FALLACY we discussed earlier known as the AD HOMINEM FALLACY (more Latin again; see Chapter 2, page 30). We commit this FALLACY whenever we irrelevantly attack the person instead of dealing with the truth of the person's message or the cogency of his/her argument.

There is another way to look at Rush's original passage. Perhaps he is trying to show how the critics' situation is weirdly inconsistent; that without the parts of Western culture that they object to, they would not have some of the things that they value, including Stanford. If this is his intention, then his ARGUMENT could be represented as:

(2) People at Stanford criticize Western culture.
Without Western culture, much that the critics value would not exist.
↓ **The critics benefit from the culture they criticize.**

In ARGUMENT (2), the reasons given are relevant, and the CONCLU-SION does follow. Indeed, we should say that the ARGUMENT is COGENT since not only is the reasoning VALID, the PREMISSES are unquestionably true. (I hear the applause for Rush, but read on anyway.) Unfortunately, the CONCLUSION of (2) is irrelevant to the CONCLUSION that is required: Rush needs to show that the criticisms are inaccurate. So ARGUMENT (2), despite its COGENCY, commits the FALLACY OF IRRELEVANT CONCLUSION. (See Chapter 2, page 31.)

Notice that we can't get from the CONCLUSION of (2) to the required CONCLUSION, without violating the precept against AD HOMINEM reasoning: **You can't, in general, show that a statement or ARGUMENT is faulty by showing that the author of the statement or ARGUMENT has faulty traits or circumstances.**

We don't know from Rush's example just what the Stanford critics are supposed to mean by their chant "Hey, hey, ho, ho, Western culture's got to go." If they mean literally that all Western culture is evil and ought to be abolished, then their 'criticisms' are hopelessly impractical and absurd. But it would be uncharitable to take such apparent hyperbole (exaggeration, for you dittoheads who prefer to speak plainly) as the essence of the critics' charges. Presumably they mean at least to say that some of the figures of Western history have been presented in an unduly favorable light, often concealing the exploitative nature of Western development, and they want to expose these exaggerations and distortions and eliminate them through a more accurate teaching of history.

The main point about Rush's reasoning in the above passage is that it is FALLACIOUS due to the irrelevant attack on the critics of Western culture. What Rush should be doing is looking carefully at the specific charges levelled against the heroes of Western culture and showing how these charges are themselves exaggerations and distortions of history. In fairness to Rush, we should acknowledge that he

does try to do this to some extent (see the following examples in this chapter). But, alas, Rush finds it difficult to resist resorting to various forms—some quite ingenious—of logical legerdemain.

Bashing the Columbashers

Rush devotes a chapter in his most recent book to defending Western civilization against the abuse of liberal political correctness. Here's Rush defending "the Truth" against the "Columbashers" (those that criticize Columbus).

> Let's start at the beginning with America's first important dead white male—Christopher Columbus. The politically correct view of old Chris today is that . . . he brought nothing to the peaceful New World 'paradise' but oppression, disease, brutality, and genocide. . . . But . . . life was far from utopian for these people—long before Columbus. In fact, while there were certainly atrocities against Indians by white people, there were just as many— and probably to a greater degree of savagery— committed by other Indians.
>
> (*See, I Told You So*, pp. 67–68)

Here Rush is trying to refute the politically correct view of Columbus that (allegedly) maintains that "he brought nothing to the peaceful New World 'paradise' but oppression, disease, brutality and genocide." And he does this by citing the alleged fact that the Indians were at least as savage to each other as the white people were to them. His reasoning looks like this:

(1) The Indians (at the time of Columbus) were at least as savage to each other as the white people were to them.
↓ The politically correct view that Columbus brought nothing but oppression, disease, and so forth to a peaceful people is untrue.

This ARGUMENT is VALID; the CONCLUSION does follow from the PRE-MISS. And let's assume that the PREMISS is true. In other words, let's assume that ARGUMENT (1) is COGENT.

But before you dittoheads score one for Rush, notice that the politically correct view has *two* components: that the Indians were peaceful people *and* that Columbus brought nothing but oppression, disease, and so forth. Rush's evidence (his premiss) refutes the first component. That reasoning looks like this:

(2) Same PREMISS as (1)
↓ It is not true that the Indians were peaceful people.

But his evidence does not refute the second one. That reasoning would look like this:

(3) Same PREMISS as (1)
↓ It is not true that Columbus brought nothing but oppression, disease, brutality, and genocide.

Rush does not actually make ARGUMENT (3), which is a NON SEQUI-TUR, that is, the CONCLUSION simply does not follow from the PREMISS. Indeed, in the original passage Rush seems to acknowledge that Columbus did bring atrocities on the Indians. Now, if you happen to think that the most important part of the Columbashers' position is the second, unrefuted component, then Rush's 'refutation', though important (it's important to know, if true, that the multiculturalists have exaggerated the innocence of the native peoples), leaves a substantial part of the Columbashers' indictment unanswered.

A final point. Notice how Rush verbalizes the Columbashers' position: that Columbus brought "nothing but" oppression, disease, and so forth. Now it's possible that some Columbashers have put their charge this way in order to exaggerate Columbus's wickedness. But putting it this way also makes the charge easier to refute: all one need do is make a case that Columbus brought *something* (at least one thing) nondestructive to the Indians. If this way of stating his opponents' position is *his* formulation and not theirs, then Rush opens himself to the charge of committing the STRAW MAN FALLACY, that is, an intentional mischaracterization of an opponent's position in order to make the position easier to refute (see Chapter 2, page 39).

In Limbaugh on the Question of Genocide

Here's more against the Columbashers and their charge that Western development left a record of genocide against the American Indians:

> [T]here are now more American Indians alive today than there were when Columbus arrived or at any other time in history. Does that sound like a record of genocide?
>
> (*See, I Told You So*, p. 68)

The reasoning in this passage is pretty straightforward. The question is rhetorical and should be taken as asserting that there was no genocide. The reasoning my be represented as:

(1) The American Indian population is larger today than in Columbus's time.
↓ The Indian population did not suffer genocide.

The reasoning here seems to be a NON SEQUITUR. We can see this if we take an undisputable case of genocide (I am reasonably sure that Rush Limbaugh would not want to dispute it)—the Holocaust. We may suppose that some time in the next century or so, the Jewish population of Europe may reach its pre-World War II level. If it does, one could hardly take that fact as evidence that the European Jews did not suffer genocide at the hands of the Nazis.

Rush may be thinking that genocide requires the killing of *all* members of an ethnic group. In that case, no amount of time would allow for population levels to return to pre-genocide levels. But that would be an unreasonably strict interpretation of 'genocide', as the Jewish example shows.

The question is not whether there are more Jews or Indians today than there were. A more telling question is whether their populations are significantly less than they would have been had the alleged genocide not occurred. The answer in both cases seems to be 'yes'. This suggests that Rush's NON SEQUITUR is due to a FAULTY COMPARISON. He compares present Indian population with past (pre-Columbus) when he should be comparing present Indian population with what the population would have been had the killing not occurred. Or, which is even more to the point, he should be comparing the pre-Columbus American Indian population to the American Indian population at the end of the alleged genocidal period, around 1880. Estimates that this writer has seen suggest that the population was reduced from about one million to less than 30,000 over that period of time. And that does *sound* like genocide, although it doesn't tell us what percentage of these population reductions was due to disease and other causes not ordinarily counted as genocidal.

Frankly, I don't have the evidence to say whether or not the American Indian was a victim of genocide, and it may be that no one else does either. Admittedly, that seems to leave us in Limbaugh, so to speak, on the question of genocide. But remember, that question is very different from the question which mainly concerns us, namely whether Rush's ARGUMENT is COGENT. And on that question the answer is pretty clear, for all the reasons given.

Doing the Limbaugh with the Pilgrims

Next we take a look at Rush the revisionist historian who claims that much of the Pilgrim story has been intentionally withheld by liberal educators, because it reveals the importance of our conservative heritage—especially its religious values and free market principles.

> But guess what? There is even more that is being deliberately withheld from our modern textbooks. For example, one of those attracted to the New World by the success of Plymouth was Thomas Hooker, who established his own community in Connecticut—the first full-fledged constitutional community and perhaps the most free society the world had ever known. . . . Nevertheless, the Pilgrims . . . of early New England are often vilified today as witch-burners and portrayed as simpletons. To the contrary, it was their commitment to pluralism and free-worship that led to these ideals being incorporated into American life. Our history books purposely conceal the fact that these notions were developed by communities of devout Christians who studied the Bible and found it prescribes limited, representative government and free enterprise as the best political and economic systems. There is only one word for this, folks: censorship.
>
> (*See, I Told You So*, pp. 72–73)

In the above passage Rush is trying to persuade the reader that public school teaching of history is censored because educators in-

tentionally omit and distort facts to hide the truth about the Pilgrims' religious values upon which our country was founded. The reasoning looks like this:

**(1) The Pilgrims' religious values provided the foundation for this country.
This fact is either distorted (by making them out to be simpletons and witch-burners) or concealed by history books.
↓ Our history books are censored.**

This ARGUMENT is VALID. The CONCLUSION does follow from the PREMISSES. Rush's use of the term 'censorship' is a bit unusual, but the effect is the same: important information is distorted or withheld from the public. But are his PREMISSES warranted?

Logicians do best when they are attending to the problem of the *logical connection* between PREMISSES and CONCLUSION, in other words, the problem of VALIDITY. The question of the truth of the PREMISSES is usually best left to experts in the various fields concerned (such as history or political science). In this case a little knowledge of history can help us see the QUESTIONABLE PREMISS in Rush's reasoning. Indeed, the second PREMISS is questionable because, as Rush fails to mention, the political system that the Pilgrims established in Massachusetts was not really one which reflected the political ideals so revered by the Founding Fathers in the Declaration of Independence and the U.S. Constitution a century and a half later.

The Pilgrims' Massachusetts society was an oppressive, intolerant theocracy which dominated Massachusetts life for seventy years. It was the antithesis (the opposite, for you dittoheads who like plain talk and don't like dictionaries) of the American political ideal. Thomas Hooker, Roger Williams (who founded Rhode Island), and other seekers of religious freedom, were driven out of Massachusetts in the 1630s. It's also worth mentioning here that the Pilgrims tried to impose detailed wage and price controls and were by no means ideological friends of 'free enterprise'.

The fact that Rush leaves out this little bit of history makes him open to the charge of committing the FALLACY OF OMITTED EVIDENCE.

Rush's characterization of the history books as "censorship" may, ironically, have a measure of truth. But not on the basis of the facts he cites, but rather on the basis of the *facts that he omits.* In so far as public school history books fail to mention the anti-democratic tendencies of Pilgrim Plymouth, the books could be charged with censorship. But I would guess that this kind of censorship would be found to be more objectionable to the multiculturalists than to Rush Limbaugh.

Rush and Animal Rights

Is His Bark Worse Than His Bite?

Rush doesn't think much of the animal rights movement. This is not to say, of course, that Rush advocates or tolerates cruelty to animals. He does tolerate animal experimentation, hunting, and meat-eating, although presumably he would either deny that these activities are really cruel or, if cruel, insist that they are justified by the value they provided to human beings. In any case Rush thinks that animals are too far removed from humans in both intellect and morals to have rights. It's not that this is not a defensible position; it's rather that some of Rush's ARGUMENTS for it and against his opponents are, to put it politely, less than COGENT. (For you dittoheads who like plain talk, we might say that some are real Lulus.)

Animal Rights and Logical Wrongs

Here's Rush arguing head-on against the doctrine that animals have rights.

> Rights are either God-given or evolve out of the democratic process. Most rights are based on the ability of people to agree on a social contract, the ability to make and keep agreements. Animals cannot possibly reach such an agreement with other creatures. They cannot respect anyone else's rights. Therefore they cannot be said to have rights.
>
> (*The Way Things Ought To Be*, p. 103)

There's little doubt what Rush's intention is here: he wants to establish the CONCLUSION that animals don't have rights. The passage seems to contain two separate ARGUMENTS for this CONCLUSION. One ARGUMENT proceeds from the PREMISS that rights have only two possible sources: God or the democratic process. The second ARGUMENT proceeds from the PREMISS animals lack the ability to make promises, said to be a condition for most rights.

The first ARGUMENT is a little difficult to spot because one of its PREMISSES is left unexpressed. Restored, the ARGUMENT looks like this:

(1) Rights are either God-given or they evolve out of the democratic process.
Animals have no rights that are either God-given or evolved out of the democratic process. (Unexpressed PREMISS)
↓ Animals have no rights.

This ARGUMENT is VALID, no question about it. But its COGENCY is doubtful owing to doubts about the PREMISSES. Rush doesn't provide

any evidence for them, and it's not clear how one could, if challenged, provide good evidence for them.

Let's take the first PREMISS. It makes the existence of rights in pre-democratic times dependent on the existence of God. According to this view, if there is no God, then there were no rights in the world until they evolved by democratic processes. This means that if it happens that there is no God, then the institution of slavery violated no human rights until the nineteenth century when democracies articulated such rights. This view also seems to make our knowledge of God more basic than our knowledge of rights, in the sense that knowing whether slaves had certain (unacknowledged) rights depends, ultimately, on knowing what God did or did not will.

Many philosophers have thought such a position untenable, and have argued that human rights exist objectively in nature independently of God, if there is a God; and while such rights may come to be eventually *recognized* by democratic systems, the existence of those rights is also independent of being so recognized. Plato held such an 'independent' view regarding value generally, and Kant held such a view regarding human rights specifically.

Of course, the fact that great philosophers have held this view does not make it true. The point, however, is that such a view is a reasonable possibility which has as much *prima facie* plausibility as the two alternatives that Rush offers in his first premiss. At least it ought not to be simply excluded from our list of alternative views regarding the nature and origin of rights. The fact that Rush has done so leaves him open to the charge of FALLACY OF FALSE ALTERNATIVES. (See Chapter 2, page 39.)

Let's look briefly at Rush's second PREMISS in (1). It's true only if it's true that God has not given rights to animals. Has He? How in Heaven's name (if you will pardon the pun) is one supposed to get evidence for such a claim one way or the other? Claims about what God has or has not done, or about what God does or does not believe, are notoriously difficult to verify. And this difficulty exists even if we assume that there is a God (another difficulty) and even if we assume that the Bible is His word (yet another difficulty). The Bible, at least in the Old Testament, gives little reason to believe that God has given animals any rights. But quite apart from the difficulty of taking the

Bible as the word of God (He explicitly condones slavery in Leviticus), there are other (non-Judeo-Christian) sacred writings with a claim to divine inspiration (for example, the Hindu Vedas) which could provide a *prima facie* basis for animal rights. For this reason Rush may be charged with the FALLACY OF QUESTIONABLE PREMISS.

Rush's second ARGUMENT seems to be this:

(2) Most rights are based on the ability to make and keep agreements.
Animals have no such ability.
↓ Animals don't have rights.

If this is Rush's intention, we should notice that the ARGUMENT has PREMISSES that are incontestable. But it is INVALID because it commits the FALLACY OF HASTY GENERALIZATION. One could equally well argue that since most hepatitis cases are based on the B-virus, and since Jones doesn't have the B-virus, he doesn't have hepatitis.

For (2) to be COGENT, Rush needs to claim that *all* rights are based on the ability to make and keep promises. So why does he say 'most'? Why doesn't he say 'all'?

The answer is that it is not true—as Rush no doubt realizes—that all rights are based on the ability to make and keep promises. We recognize the existence of rights in many cases where that ability does not exist. For example in the cases of children, various kinds of mentally defective people, including the insane, the retarded, and people in comatose states. In all these cases, the individuals are afforded the right to life, for example. This shows that not all rights depend on the ability mentioned. So what is the right in these cases based on? You might want to say that it is based on the fact that all these cases are human beings. That would be okay, provided that we don't assume, without ARGUMENT, that *only* human beings have rights. That, after all, is the original point at issue, and to make that assumption, without ARGUMENT, would be to commit the FALLACY OF BEGGING THE QUESTION. (See Chapter 2, page 41. You dittoheads will be happy to know that Rush does not commit that FALLACY, at least not here.)

But let's back up for a moment. Perhaps (2) does not fairly reflect Rush's intention. Perhaps he means to say that these rights based on

the ability to make and keep agreements are the rights other than the ones given by God. They would be the ones he had just described as "evolved out of the democratic process." And, if they make up the majority of rights, he would naturally express this fact by the first PREMISS of (2). If so, then Rush's ARGUMENT is really an elaboration of ARGUMENT (1) but stated in terms of the essential feature of evolved rights, namely, the ability to make and keep agreements. On this interpretation Rush would have only one ARGUMENT which could be represented as:

(3) Rights are either God-given or they are based on the ability to make and keep agreements.
Animals have no rights that are either God-given or based on such an ability.
↓ Animals have no rights.

This ARGUMENT, like (1), is VALID but, also like (1), suffers from QUESTIONABLE PREMISSES.

A final thought. I have been taking Rush's CONCLUSION in this passage as saying that no (non-human) animals have any rights. This CONCLUSION might be true, and in showing that Rush' ARGUMENTS are not COGENT we have not established the falsehood of the CONCLUSION. (This general point about reasoning was made in Chapter 1, page 4, and Chapter 2, page 26.) But there may be reason to think that his CONCLUSION is false. Usually, when the issue of animal rights arises, it is the right to life that comes to mind. But there may be other rights which animals possess even if they don't possess that one. Here's a candidate which seems at least as plausible as the right to life: the right not to be treated cruelly. Indeed, this right would seem to extend to *any* sentient creature, not because of its intelligence or ability to make and keep agreements, but because of its *capacity to suffer.*

This suggestion brings us to another of Rush's ARGUMENTS concerning animal rights.

The Most Unkindest Cut of All

The following example is apparently intended to persuade us that animals fail to have a specific right, a right to kindness.

> One woman called my show to protest that animals do at least have one right: to kindness. I told her she was mistaken. Look at what they do to each other. They tear each other limb from limb.
>
> (*The Way Things Ought To Be*, p. 105)

Again, the reasoning here is pretty straightforward. Rush is arguing that animals don't have a right to kindness because of the way they behave toward one another. And I will assume that he and the caller mean by 'right to kindness' roughly 'right to be treated humanely', and that this right is essentially a right against cruel treatment. (I realize that 'kindness' usually connotes more positive behavior. But I think the PRINCIPLE OF CHARITY requires that Rush should make the most favorable interpretation of the caller's case. That is, he should take the term in its minimal sense as a right against cruel treatment.) Here's the essential argument:

(1) Animals tear each other limb from limb.
↓ Animals do not have a right to kindness.

Apparently Rush thinks that the savagery and brutality of beasts in the wild ("tear each other limb from limb") disqualifies animals from possession of the right to kindness. But if (1) is to be VALID, Rush must be committed to something like the unexpressed PREMISS that whatever tears its fellow creatures limb from limb does not have a right to kindness. Let's show this as:

(2) Animals tear each other limb from limb.
Whatever tears its fellow creatures limb from limb does not have a right to kindness. (Unexpressed PREMISS)
↓ Animals do not have a right to kindness.

The problem with (2) is its PREMISSES. Take the first PREMISS. Rush is probably thinking of flesh-eating mammals, like lions and tigers. The PREMISS is true of those kinds of animals. But there are many kinds of animals that don't routinely tear each other limb from limb, for example, gorillas and dolphins to mention but two. So Rush's general statement had best be taken to mean 'some' (rather than 'all') animals. But if so, the most that his argument can do is to prove that *some* animals do not have a right to kindness. That is:

(3) Some animals tear each other . . .
Whatever tears its fellow creatures . . .
↓ Some animals do not have a right to kindness.

This CONCLUSION follows from his PREMISSES. But it's not the CONCLUSION he needs. From this perspective, Rush's original ARGUMENT is, if valid, a FALLACY OF IRRELEVANT CONCLUSION.

Arguments (2) and (3) have another problem as well. Is the unexpressed PREMISS warranted? Apparently not, because although human beings tear each other limb from limb, both literally and figuratively (witness that uniquely human institution—war—and its more recent development—total war), we do not want to say that human beings do not have a right to kindness. (Even brutal killers are apparently not properly denied a right to kindness, at least minimally understood, inasmuch as we require their punishment, including the death penalty, to be not 'cruel and unusual'; and we do this as a matter of their right against such treatment.) What this means is that the unexpressed PREMISS is unwarranted, and the original ARGUMENT commits the FALLACY OF QUESTIONABLE PREMISS (see Chapter 2, page 31).

At this point some dittoheads might wish to defend Rush by insisting: 'There is a big difference between affording a right kindness to a criminal and affording it to an animal, because criminals are

Tearing Them Limb from Limb

human, while animals, even if they are gentle, are not.' Now this is an unusually subtle argument for a dittohead. But unfortunately, as in the previous example, this merely *assumes* rather than proves the point at issue—that only humans (not animals) have a right to kindness. In other words this defense BEGS THE QUESTION (see Chapter 2, page 41). The claim may be correct, but it needs proof.

A final comment. Rush doesn't have much to say in these passages about what a right *is*. (He does have a few things to say in a later passage. See below, page 105.) This is a very difficult subject, one that has kept the philosophers perplexed for hundreds of years, at least since John Locke's *Two Treatises of Government.* But the main idea is that if an individual has a right to X, that means that it would be a violation of that individual's right to X and therefore wrong, to deny that individual X, or to take X away from that individual. And it is a *wrong to the individual;* it is *wrong for the individual's sake.* If an animal had a right to life, for example, it would be a violation of the animal's right to life to kill it, and the act would be wrong for that reason.

Of course, there might be other reasons as well why the act is wrong, for example, the animal might be somebody's pet rabbit, and in killing it you violate *that person's* rights, namely, his/her right to property. You can see, then, that even if the animal has no right to life, it could still be wrong to kill it. The wrongness of the act, however, might derive from its wrongness to the property owner and not from any inherent wrongness to the animal *per se.*

Those who believe that animals don't have any rights, but believe that animals shouldn't be mistreated, will presumably base the wrongness of such acts on something other than an animal's right against such treatment, for example, protecting private property rights, conforming to God's commands, promoting human goodness and human happiness.

Flipper the Rapist?

In this selection, Rush tries to establish a point about male dolphins.

> The Times article [about the intelligence of dolphins]
> went on to say that researchers off the coast of
> Australia have come across male dolphins that
> engage in very chauvinistic behavior toward female
> dolphins. This activity is called "herding". "The males
> will chase after her, bite her, slap her, hit her with
> their fins, slam into her with their bodies." In other
> words, Mike Tyson behavioral rules dominate the
> male dolphin population.
>
> (*The Way Things Ought To Be*, pp. 108–09)

It's important to understand the general background here. Rush is trying to undermine the claims of the animal rights people, and others, that dolphins are such wonderful—some might even say 'noble'—creatures. More specifically Rush is trying to show that, based on the *Times* article, dolphins are much like sexist aggressors of the Mike Tyson ilk (a convicted rapist with a well-known reputation for physically abusing women). The trend of the reasoning is that because the dolphin behavior (herding) is roughly like Mike Tyson's behavior (especially toward females), Tyson's behavioral style is typical of ('dominates') male dolphin behavior. The essential ARGUMENT can be represented as:

(1) Male dolphins off the coast of Australia have been found to engage in herding (aggressive behavior towards female dolphins).
This aggression is like Mike Tyson's. (Unexpressed PREMISS)
↓ Mike Tyson behavioral rules dominate the male dolphin population.

There is a FAULTY COMPARISON here, plus at least two instances of NON SEQUITUR. His phrase "Mike Tyson behavioral rules" implies extremely aggressive and violent behavior (including rape). The behavior described in the argument (herding) may well be of a less violent nature, possibly of a playful sort and received (for all we know) by female dolphins as such. Also, the CONCLUSION that these rules "dominate" the male dolphin behavior seems unduly hasty. For all we know, herding may be limited to a relatively small period of time in the life of a dolphin.

Finally, a careful reading of the quotation from the original article suggests that the proper interpretation is that the behavior in question applies to *some* male dolphins. If so, the CONCLUSION about the entire male dolphin population would be a HASTY GENERALIZATION (see Chapter 2, page 34). The behavior may apply only to some males of a certain group of Australian dolphins.

Look What's Bugging Rush

In the next example, Rush tries to convince his readers that the concern for animals today is excessive. There's no question that Rush is injecting a heavy dose of humor in this passage. And for that reason it is inappropriate to apply the standards of cogent reasoning too strictly. But sometimes humor can be intended to disguise bad reasoning or to otherwise disarm us in our vigilance against FALLACY. Whether that is Rush's intention here is hard to say. But even if Rush is not trying to provide a serious ARGUMENT for his CONCLUSION, the example is instructive in the method of arguing from ANALOGY and how it can become faulty.

> The town of Colburn, Idaho, population 20, is going to be wiped off the map because the state wants to build a five-lane highway right through the town. It's too bad these people don't have some 20 endangered beetles or bugs in their town because then they could stop the highway. There is far more concern for animals today than for people.
>
> (*The Way Things Ought To Be*, p. 110)

Rush tells this story about Colburn, Idaho, as evidence for his claim that there is "far more concern for animals today than for people." One way to view his reasoning (admittedly meant to be humorous) is that although the state of Idaho will not alter highway construction plans to save a town of 20 people, they would alter their plans to save 20 bugs. This supposedly shows that there is more concern for animals than for people. The essential ARGUMENT would look like this:

(1) **The state will not stop the construction to save a town of 20 people from being wiped off the map.**
They would stop construction to save 20 endangered beetles or bugs.
↓ **There is more concern today for animals than for people.**

One problem with this ARGUMENT is that it is a HASTY GENERALIZA-
TION. Assuming for the moment that there is more concern for ani-
mals than for people in Idaho, that does not provide much support
for the general claim that there is (in general) far more concern for
animals than for people.

Of course, Rush is trying to be funny here. And exaggeration is
one form of humor. Besides, Rush could cite, and does cite, other
similar examples, so it is not quite fair to say that he intends this one
example to prove his point.

But there is a FALLACY OF FAULTY ANALOGY hidden here alongside
the humor. ARGUMENT by analogy is a perfectly good form of (INDUC-
TIVE) reasoning; there is nothing *per se* fallacious about reasoning by
analogy, *provided the things being compared are alike in lots of ways
and not unlike in too many, at least not unlike in relevant ways* (see
Chapter 1, page 15, and Chapter 2, page 46).

Thus, a father might argue that his son should ride his bike to
school since he (the father) did when he was a schoolboy. And the
ARGUMENT would be pretty good if the father's situation was essen-
tially the same as the son's current situation. But the ARGUMENT weak-
ens if these situations differ in significant ways, for example if the
father lived much closer to his school, or if auto traffic was much
lighter then, or if the son is much younger than his father was.

The hidden analogy in Rush's reasoning is due to a FAULTY COM-
PARISON between saving the animals and saving the town, in an im-
plied ARGUMENT to the effect that if the state would stop construction
to save 20 animals (and Rush thinks they would), then they should
also stop construction save a town of 20 people, since the people are
at least as important as animals. Here's how the implied ARGUMENT
FROM ANALOGY may be represented:

**(2) The state would stop construction to save 20 animals (bugs
or beetles).
Saving a town of 20 people would be a similar undertaking of
at least as much importance.
↓ The state should stop construction to save the town of 20
people.**

The FALLACY here (FAULTY ANALOGY) is due to the fact that there are very important differences between saving a town of 20 people and saving 20 animals. First, the 20 people, if the town is not saved, won't forever vanish from the earth on that account. They will simply relocate. But the probable effect of the highway construction would be the destruction of the animals. And, on this point, Rush seems to confuse individuals and species, since he talks about "20 endangered beetles or bugs". He means, or should mean, '20 endangered *species* of beetles or bugs'. And while it may be unreasonable to alter highway construction plans to save the lives of 20 beetles or other animals, it is not obviously unreasonable to do so to avoid the extinction of 20 endangered animal species.

Some Rights Aren't Rights— Right?*

Here's yet another, though more substantial, piece of reasoning concerning animal rights.

> The point is that animals do not have rights but are accorded protection [under law] by human beings. Chris Huson [a listener] illustrated the difference [between rights and laws] by observing that the 'right to privacy' is not a right, but a protection granted by the government. The 'right to privacy' does not allow you to take drugs in your car or home with impunity. . . . He further stated that the basic right to life of an animal—which is the source of energy for many animal rights wackos—must be inferred from the anti-cruelty laws humans have written, not from any divine source. Our laws do not prevent us from killing animals for food or sport, so the right to life of an animal is nonexistent. . . . He is right and I don't think it can be stated much better.
>
> (*The Way Things Ought To Be*, pp. 112–13)

Contrary to Rush's claim, this is a very confusing and confused piece of reasoning. Whether the fault is primarily Rush's or his

*Warning: The degree of difficulty in the following selection may cause BSS (brain strain syndrome) in some dittoheads. Curious dittoheads may proceed at their own risk. The less curious are advised to turn to a less challenging selection or, even safer, turn on their favorite radio talk show.

listener's is hard to say. The reasoning is complex; several arguments and fallacies can be discerned, some errors more serious than others. One kind of mistake that Rush makes, or (let's be charitable) comes very close to making, is his reasoning that a certain claim is true just because some listener stated that it was true. Here's the reasoning:

(1) Chris Huson says that animals don't have a basic right to life, only protection derived from anti-cruelty laws.
↓ They don't have a basic right to life.

This fallacy is known as the APPEAL TO INAPPROPRIATE AUTHORITY (see Chapter 2, page 44). There is not a fallacy *per se* in appealing to an authority to support some point of view (though, of course, no authority can provide complete support for the point of view; it doesn't necessarily follow that the point of view is true just because the authority says so). It would be no fallacy to argue that since the *Encyclopedia Britannica* says that George Washington died in 1799 that, therefore, he (probably) did.

But an appeal to authority is weak and fallacious whenever: a) the authority's credentials are inappropriate (he/she is really no authority or an authority in some other, unrelated, field); b) the authority is biased; or c) the authority has a poor track record. It is also a useless appeal in those cases where the experts in the field hotly disagree, as is the case with animal rights, as professional philosophers well know. Here, as in any area where the experts disagree, one must become one's own expert and examine the facts and ARGUMENTS oneself and attempt to come to a CONCLUSION.

Fortunately, Rush's original reasoning is not simply an appeal to authority. He argues that the (so-called) 'right to life' for animals is really not a right but (merely) a protection under law. He illustrates the difference between protection under law and rights by example of the 'right to privacy,' which he says is not really a right because it has limitations on what it allows. With the addition of an unexpressed PREMISS, we can show this ARGUMENT as:

(2) The 'right to privacy' does not allow you to take drugs in your home.

True rights don't have such limitations. (Unexpressed PREMISS)
↓ The 'right to privacy' is not a right, but a protection (law)
granted by the government.

Apparently, Rush construes rights as absolutes in the sense that they *can't* be taken away or limited by government. But if this is what he means, then, by his own account, it would seem that there couldn't be *any* true rights. The 'right to freedom of speech' could not be a true right since it is limited (it doesn't allow you to yell 'fire!' in a crowded theater, or slander your neighbor). So too, the 'right to possession of property' could not really be a right since it too is limited (by the state's right of eminent domain). But freedom of speech and possession of property are paradigm cases of rights as we ordinarily understand the term. If these are not really rights, then what are? Rush doesn't say. I think we have to say, therefore, that either ARGUMENT (2) is a NON SEQUITUR (the CONCLUSION simply doesn't follow from the PREMISS) or the unexpressed PREMISS (that true rights aren't limited) is a QUESTIONABLE PREMISS.*

After trying to make the distinction between genuine rights and mere protections, Rush also argues that since our laws do not prevent us from killing animals for food or sport, those laws are not grounded in a basic right to life for animals:

(3) Our laws (or the 'right to life' of animals) do not prevent us
from killing animals for food or sport.
↓ The right to life of an animal is nonexistent and is derived
from anti-cruelty laws.

As in (2), it seems that here too, Rush's reasoning depends on the doubtful assumption that genuine rights are not limited. It also looks

*There is also another very curious error here which students of the U.S. Constitution may have noticed in Rush's argument that the right to privacy is not a true right. US law recognizes the right to privacy as based on the Ninth Amendment. But the Ninth Amendment is special in that it clearly refers to other rights not enumerated in the Constitution, but nonetheless "retained by the people". Thus it is a finding of the law that there are pre-existing rights independent of the law, one of which is the right to privacy. Hence, the oddness of Rush's denial that the right to privacy is "not a right, but a protection granted by government."

in (3) as if Rush may be committing the FALLACY OF INCONSISTENCY. If there is no right to life for animals, then how can it (the right to life for animals) be "derived from" anything? (Imagine if someone said, correctly, that the word 'dittohead' is derived from Rushian, but added that it was 'nonexistent'.) What Rush means, of course, is that the right to life for animals does not exist *as a basic (fundamental, non-derivative) right.* But, as we observed above, there just don't seem to be any basic rights (in his sense of the term)—at least Rush hasn't provided us with any examples.

There is another confusion bound up with (2) and (3) which needs to be pointed out. Compare ARGUMENT (3) with the following:

(4) Our laws do not prevent us from killing animals (for food and sport).
↓ Our laws do not *recognize* a (basic) right to life for animals.

This ARGUMENT is *not* fallacious. But it is not the ARGUMENT that Rush wants to make. He wants to establish the very different CONCLUSION that *there is* no (basic) right to life for animals, not merely that *we recognize* no such right. In other words, Rush has confused two different sense of 'not having a right' (objectively failing to have it as distinct from not being recognized as having it) and, as a result, has failed to see that one could possess a right even though one's society failed to acknowledge one's possession of that right. The Jews in Nazi Germany, for example, surely had a right not to be interned in concentration camps, although that right was not acknowledged by the state.

This confusion is also an instance of confusing what *is* (or *is not*) with what *ought to be* (or *ought not to be*). Just because a right is not recognized does not mean that it ought not to be recognized. This error could be categorized in several ways. Since Rush's CONCLUSION in (3), the CONCLUSION he wants to establish, does not follow, he commits a NON SEQUITUR. Since he confuses two distinct senses of 'having a right' he commits the FALLACY OF EQUIVOCATION (see Chapter 2, page 34). And since his equivocation involves a confusion between the *is* and the *ought,* he has committed the IS-OUGHT FALLACY (a version of which is known as the *naturalistic fallacy*).

Finally, notice that the original passage seems to be intended to establish the general point that 'animals do not have [basic] rights.' If Rush means that animals have *no* basic rights (as I think he does), this is obviously not going to follow from his CONCLUSION that animals have no right to life. That ARGUMENT would be:

(5) Animals do not have a (basic) right to life.
 ↓ Animals do not have any (basic) rights.

That would be a HASTY GENERALIZATION (see Chapter 2, page 34).

What Rush seems to have in mind is an ARGUMENT based on the idea that all so-called animal rights are, like the example of the right to life, confusions between rights and laws. He doesn't actually develop this reasoning in the original passage, but presumably he could, and the ARGUMENT would look something like this:

(6) The claim that animals have a basic right to life is false due to a confusion between rights and laws (as explained by Rush's listener).
 All other animal rights claims similarly confuse rights and laws.
 ↓ All other animals rights claims are false, i.e., animals have no rights.

This ARGUMENT is VALID. The CONCLUSION does follow from the PREMISSES. But for the reasons already given, there is little or no good reason to think that these PREMISSES are true.

Rush on Sex Education

6

What You Don't Know Can Hurt You

The examples comprising this chapter concern a subject dear to Rush's heart: sex education. His general position is that sex ed is yet one more intrusion of government into our private lives, and one that is especially offensive because sex is such an intensely personal matter. This position is certainly understandable even for those (mainly liberals) who do not share this sense of impropriety about (public) sex education. Of course, Rush goes beyond this level of objection and argues, often carelessly, about the allegedly harmful effects of sex education on adolescent behavior. In the course of so doing, he draws questionable causal inferences and uses FAULTY ANALOGIES, SUPPRESSED EVIDENCE and QUESTIONABLE PREMISSES.

Sex and Drugs: Just Say 'No No'

In our first example, Rush attempts to refute a sex education advocate on the basis of an analogy that omits some relevant differences between sex and drugs.

> Chancellor, Joseph Fernandez, vigorously fought the idea [of teaching abstinence in the sex education program], saying it would do great damage to their existing program! . . . This is tantamount to opposing a drug education program which instructs students not to use drugs because it would not be useful.
>
> (*The Way Things Ought To Be*, pp. 132–33)

The main reasoning here is an ARGUMENT BY ANALOGY (see Chapter 2, page 46), and it is based on the alleged similarity of sex education and drug education when it comes to abstinence. Rush implies (but doesn't actually say) that because opposition to abstinence in the case of drugs would be absurd, it is equally absurd in the case of Fernandez's sex education program. We may represent the reasoning as:

(1) A sex education program is like a drug education program (as regards the role of abstinence).
It would be absurd to oppose abstinence from drugs on the grounds that it would be not be useful.
↓ Fernandez's position (that teaching abstinence in sex ed would not be useful) is absurd.

What we have here is a FALLACY OF FAULTY ANALOGY. We should recall that ARGUMENT by ANALOGY is not fallacious *per se*, provided that the things being compared are not unlike in relevant ways. When

we look at Rush's analogy, we can see some important differences between drug education and sex education. Some of the main differences include the facts that: 1. one can, with proper sex education, avoid (or dramatically increase one's chances of avoiding) the bad consequences of sex (disease, unwanted pregnancy) without abstaining from sex, whereas one cannot (or not very easily) avoid the bad consequences of drugs (addiction, jail) without abstaining from drug use; 2. drugs are illegal, sex is not; 3. human interest in sex, but not in drugs, is rooted in a biological drive, an instinct. For these reasons, at least, Rush's analogy is weak.

Flying Condoms

In this example, Rush turns his logical guns on the condom.

> The worst of all of this is the lie that condoms really protect against AIDS. The condom failure rate can be as high as 20 percent. Would you get on a plane—or put your children on a plane—if one in five passengers would be killed on the flight?
> (*The Way Things Ought To Be*, p. 134)

This bit of reasoning is relatively simple. Rush is apparently trying to convince his audience that it is a "lie" that condoms really protect. This seems to be the main conclusion. And toward establishing that conclusion he argues that using a condom (or recommending its use to our children) is like flying on an airplane (or having our children fly on one) that has a 20 percent chance of crashing—obviously an irresponsible risk. The heart of the reasoning depends on an analogy between flying on a plane with a 20 percent chance of crashing and having sex using a condom with a 20 percent chance of failing. Here's the essential reasoning:

(1) Condom failure rate can be as high as 20 percent. Using a condom with a 20 percent failure rate is like flying with a 20 percent chance of a fatal plane crash (both risk death).
No responsible person would fly with a 20 percent chance of fatally crashing. (Unexpressed PREMISS)
↓ No responsible person would use condoms to prevent AIDS. (Implied)
↓ The claim that condoms protect against AIDS is a lie.

This is an especially instructive example because it illustrates the three general kinds of FALLACIES in one relatively simple piece of reasoning (INVALIDITY, UNWARRANTED PREMISSES, OMITTED EVIDENCE—see Chapter 2, page 24).

First, even if no responsible person would use condoms to prevent AIDS, the second conclusion does not follow. A *lie* ordinarily is a false statement *made with the intention to deceive*. But even if the claim about condom protection is false, nothing Rush says even begins to establish that it has been made with the intention to deceive. Hence, his reasoning, as an ARGUMENT for the second CONCLUSION in (1), is a NON SEQUITUR (and therefore INVALID); the CONCLUSION does not follow from the PREMISS. (And notice that if Rush intends to support the assertion that the claim is merely false, rather than a lie, his own evidence that condoms do not "fail" at least 80 percent of the time surely suffices to establish the truth of the statement that "condoms really protect against AIDS", though admittedly it's not perfect protection.)

Second, his condom failure rate, as a general statistic, is suspect, even if it "can be as high as" he says. The phrase "can be as high as" is a weasel phrase which has little relevance in this argument. No doubt somewhere there is a batch of condoms all of which are defective and which therefore prove the claim that the failure rate "can be as high as" 100 percent. Obviously, this won't do as a statistic about condoms generally.

According to *Consumer Reports* (March 1989), of 40 brands tested, 32 had a failure rate of 1.5 percent or less; 6 had a failure rate of 4 percent or less; and only 2 brands had a failure rate of more than 10 percent. I conclude, therefore, that Rush's figure of 20 percent, as a general statistic about condom failure, makes his argument a fallacy of UNWARRANTED PREMISS.

(A further difficulty here has to do with the definition of 'condom failure'. If we extend the idea of condom failure to include failure due to human error, that is, to misuse, then the failure rate, though harder to measure, would no doubt be closer to 20 percent (though one would expect it to decline with increased sex education and perhaps also with instruction in less risky sexual activity . . . calling Dr. Elders). But sources I have seen indicate that even by that definition, 20 percent is too high as an average figure.)

Finally, we should notice that the second PREMISS in (1) makes a FAULTY COMPARISON which fails to mention an important difference

between the danger from condom failure and that from plane crashes. An airplane crash is tantamount to death; a condom failure is not. This makes the reasoning a FALLACY OF OMITTED EVIDENCE.

We can fully agree with Rush that it would be irresponsibly risky to fly with a 20 percent chance of crashing. He is obviously comparing being killed in a plane crash to dying of AIDS. The trouble is, even if we use the 20 percent condom failure rate that Rush claims, the chance of dying of AIDS if one uses a condom for sex is very much smaller than 20 percent.

That probability is the product of the probabilities of the component conditions involved in the behavior in question. Specifically, it would be: a) the chance of condom failure multiplied by b) the chance that your partner is infected with the virus; multiplied by c) the chance that you will contract the virus from an infected partner if unprotected.

The percentage of the population with AIDS or HIV varies from group to group, of course. Among the teenage population it is rising, but is almost certainly less than 5 percent. Let's say 10 percent to be safe.

Experts differ in their estimates of the sexual transmissibility of the virus, though it is known to be more easily transmitted from men to women than vice versa. Most estimates of the chance of transmission (from men to women) by ordinary vaginal intercourse are in the range of 1 in 100 to 1 in 500 per sex act.

I will use the more conservative estimates (Rush would want it that way). In this context, that means the most gloomy estimates. Let's assume the worst. I will accept Rush's condom failure rate, exaggerated though it is.

To find the probability of dying from AIDS because of one act of sex using a condom, we have to multiply 20 percent (the condom failure rate) by 10 percent (the chance that your partner has HIV), and then multiply again by 1 percent (the chance that you will get the virus from an infected partner).

Since some readers may not be used to multiplying percentages, let's convert these to fractions. Twenty percent means one-fifth. Ten percent means one-tenth. One percent or "one in a hundred" means one-hundredth. So:

$$\frac{1}{5} \times \frac{1}{10} \times \frac{1}{100} = \frac{1}{5,000}$$

The answer is one-five-thousandth (or 0.02 percent). This is *one thousand times smaller* than the 20 percent (or one in five) death rate claimed by Rush.

Using a condom cuts your risk of death from AIDS to one-fifth of what it would be without the condom. In other words, on average, without a condom, you would have to have vaginal intercourse one thousand times, in order to catch the lethal HIV, whereas with a condom, you would have to have vaginal intercourse five thousand times.

Now let's get real, my dear dittoheads. Suppose that a condom fails, not once in five times, but once in a hundred times. Then your chance of catching HIV from one act of ordinary vaginal intercourse, with a properly used condom, is one in a hundred thousand (0.001 percent). On average, a person would need to have intercourse with a condom a hundred thousand times to die of AIDS. This is probably not very different from your chance of being struck by lightning while on your way to church.

He's Talking Through His Condom

In this example, Rush tries to use a gag about "Safe Talk" to prove a point about "Safe Sex". This stunt caused paroxysms of laughter from Maine to California. (It also required a measure of courage inasmuch as it was received by a prudish few as in bad taste even if it was good theater.) But humor notwithstanding, his recount of the 'logic' of his stunt contains a bad analogy (and even if Rush and most of his listeners don't take the argument seriously, there's the danger that some might).

> Of course, I then pointed out that the reason my show practiced Safe Talk had nothing to do with the condom stretched over my studio mike. It was because I had chosen not to say anything offensive or profane. The only way to ensure Safe Talk was for me and others in the radio business to practice prudent behavior. To exercise self-restraint. Using a condom for Safe Talk or Safe Sex was an evasion of moral responsibility.
>
> (*The Way Things Ought To Be*, p. 135)

The underlying reasoning makes a comparison between using a condom for safe sex and safe talk, concluding that because one sort of use is inappropriate, therefore the other is as well.

(1) Putting a condom over the mike to achieve 'safe talk' is like using a condom to achieve 'safe sex'.
Putting a condom over a mike is silly; prudent behavior (self-restraint) is required.

↓ Using a condom for 'safe sex' is silly, and the appropriate behavior is self-restraint.

There are some important differences between the two cases (the two uses of the condoms) which spoil the comparison and which make argument (1) an instance of the FALLACY OF FAULTY ANALOGY. Perhaps the most important difference is that the condom over the mike not only excludes 'unsafe' (profane) talk, it excludes *all* talk. By contrast, using a condom for safe sex does not exclude all sex, only unprotected sex. Thus, while a condom over a mike is obviously an unreasonable way to ensure 'safe talk', it is not at all obvious that using a condom to ensure safe sex is equally unreasonable.

Rushian Roulette (with the Safety On)

Here's Rush yet again doing battle with the condom and liberal advocates.

> Liberals tell kids in schools all over America that the best way to protect themselves from AIDS is to wear condoms while engaging in sexual intercourse. It's a lie. They are imposing a death sentence on kids. The failure rate for condoms is around 17 percent. They're teaching kids to play Russian roulette.
>
> (*See, I Told You So*, p. 222)

This passage has no clearly marked argument indicators (like 'because' and 'therefore'). But his main point seems to be his assertion in the second sentence that the liberal message about condoms is "a lie". Presumably it is a lie because the advice amounts to a "death sentence". And this is so apparently because of the condom failure rate given as 17 percent). This reasoning may be represented as a complex of two ARGUMENTS:

> **(1) The failure rate for condoms is around 17 percent.**
> **↓ Liberals (who promote condoms as protection from AIDS) are sentencing kids to death.**
> **↓ The liberal claim that condoms protect from AIDS is a lie.**

Both inferences in (1) are FALLACIOUS, although they go wrong in different ways. In the first, Rush neglects to mention that the alternative (no condom education) would likely result in even more deaths. This makes the reasoning a FALLACY OF OMITTED EVIDENCE. One might as well argue that advocating the use of seat belts is tantamount to a death sentence because the belt sometimes fails (with fatal conse

Rushian Roulette

quences). The fact is that those who advocate condom education agree that there should be full disclosure of the risks of protected sexual intercourse, as well as those of other alternatives, including abstinence.

Rush's second inference is a NON SEQUITUR. Even if we decide that protected sex is unacceptably risky and that only abstinence should be taught, it still would not follow that the advocacy of condoms to protect against AIDS was a *lie*. A lie, after all, must include an intention to deceive, and Rush has provided no reason to believe that liberal advice on AIDS prevention is not sincere.

Notice also that Rush seems guilty of creating a bit of a STRAW MAN FALLACY when he says that kids are told the condoms are "the best way" to protect against AIDS, thereby implying that educators don't mention abstinence as a more effective alternative. Are we to believe that this is a typical, or even frequent, occurrence in American public school sex education programs? According to a 1994 Roper Starch poll, 72 percent of the 503 high school students surveyed reported that they had participated in sex ed classes. Of these, 93 percent said that "abstinence from sex" had been covered.

Rush's Sex Shops

Here's more on sex education and (you guessed it) the condom.

> Their rationale [for promoting condoms]? They're going to do it anyway, . . . maybe they would support me if I were to open . . . a chain of Rush sex shops. Operating under the philosophy that they're going to do it anyway, I can provide the nurses [to] coach the little toddlers in the art of condom usage . . . adult beverages to enhance their foreplay And since we all know they are also going to take guns to school, I can . . . sell guns, too.
>
> (*See, I Told You So*, p. 222)

There is an ARGUMENT BY ANALOGY in this passage. Rush is clearly trying to convince us that the (alleged) liberal rationale for providing condoms to school kids ("they're going to do it anyway") is ridiculous because the rationale would obviously fail to justify providing toddlers with sex and booze, and school kids with guns.

In this passage Rush appeals to an alleged similarity between saying that school kids should have access to condoms because they're going to do it anyway, and saying that school kids and toddlers should have access to sex, booze, and guns because they're going to do it anyway. From the similarity he implies by analogy that since the access is obviously a bad idea in the latter cases (sex, booze, and guns), it is also a bad idea in the former (condoms). Notice that the implication is clear even though he doesn't explicitly state the entire ARGUMENT BY ANALOGY. (See Chapter 2, page 46.) The essential ARGUMENT may be represented as:

(1) Giving kids condoms because they're going to do it anyway, is like giving toddlers and school kids sex, booze, and guns because they're going to do it anyway.

123

Giving toddlers and kids sex, booze, and guns, because they're going to do it anyway, is obviously a bad idea. (Unexpressed PREMISS)
↓ Giving kids access to condoms, because they're going to do it anyway is equally a bad idea. (Implied)

Notwithstanding Rush's attempt at humor here, we have a FAULTY COMPARISON owing to OMITTED EVIDENCE. The rationale for providing condom education is that a large percentage of kids will have sex even if they are advised not to. And since unprotected sex is much more dangerous than protected sex, the use of condoms can save lives (and prevent pregnancy). Little toddlers aren't "going to do it anyway", and the chances of preventing sex among them is virtually 100 percent.

As for kids and guns, it doesn't seem true that "they're going to do it anyway". There are effective ways to prevent it, unlike sex among horny teenagers. *If* there were an equally irrepressible instinct to take guns to school, the response analogous to giving condoms would not be, as Rush says, to supply the kids with guns, but to provide knowledge of the risks of guns, offer instruction in safe use (including 'abstinence'), and issue, for the majority of risk takers who can't or won't overcome their 'instinctive behavior', blank ammo.

A final note. There is a related but separate ARGUMENT that Rush might wish to make in this discussion, and that would be an ARGUMENT based on the claim that making condoms and condom education available to kids is bad because this gives official sanction to premarital sex. This is a complex and controversial issue involving difficult questions concerning the effects of social policy on human behavior. (It is also an area where logicians and talk show hosts may have more noise than light to shed.) Complexity notwithstanding, a couple of points to bear in mind. A school condom program needn't be construed as official sanction of premarital sex any more than the availability of erasers on pencils need be taken as official sanction of bad math. This is especially so if a condom program also counsels abstinence (and, possibly, Dr. Elders's exercise). But a more difficult question is whether such a program would, nonetheless, result in in-

creased premarital sex. It might. But this increase might be an increase in sex that is safer, and the net result might well be societal improvement in terms of disease and illegitimacy.

Telling It Like It Isn't

Here's Rush drawing a HASTY CONCLUSION concerning the alleged effects of a liberal sex education.

> Why does it surprise anyone that kids are acting out their sexuality more overtly when the schools are giving out condoms and insisting that there's no way to discourage teens from having sex? . . . Kids are told there are no differences between boys and girls, . . . that there is no such thing ultimately as right and wrong. Values are relative. Truth is relative. . . . If that isn't a recipe for sexual harassment and other forms of sexual and physical abuse, I don't know what is.
>
> (*See, I Told You So*, pp. 206–07)

In the above passage Rush is attributing the rise in teenage sexual activity to public school sex education. His argument looks like this:

(1) Kids are getting a liberal sex education (as characterized by Rush).
Kids are becoming more sexually active and abusive.
↓ The rise in sexual activity is the result of liberal sex education.

In the first place, one may reasonably doubt whether many kids are actually getting a liberal sex education as characterized by Rush—whether Rush's description is accurate or typical of American public schools. If his account should prove to be unduly exaggerated, Rush's reasoning involves a QUESTIONABLE PREMISS, and his criticism of the liberals and their educational philosophy would be a STRAW MAN FALLACY. (Not only is it not nice to mischaracterize your opponents' position in order to make it easier to refute—it's a fallacy. See Chapter 2, page 39.)

But apart from this, when we ask 'Does sex education cause sex abuse and sexual activity among kids?' it is very important to see that this is a very different question from 'Has there been an increase in these things among kids?' Unfortunately, Rush seems to assume that because an increase in teenage sexual activity has accompanied an increase in sex education therefore the latter causes the former. But one could equally well argue that an increase in teenage sexual misbehavior has accompanied an increase in the popularity of Rush's radio show and that, therefore, Rush must be the cause. That argument would look like this:

(2) Over the last eight years there has been a marked increase in the number of teenagers who listen to and watch Rush Limbaugh.
During the same period there has been a significant increase in sexual activity among the teenagers.
↓ The rise in sexual activity is due to Rush Limbaugh.

The point is that mere concomitance or correlation does not prove causation. So Rush's argument commits the FALLACY OF QUESTIONABLE CAUSE (see Chapter 2, page 36).

Finally, even if sex education has caused an increase in sexual activity, we must ask whether that activity is not of a less socially destructive sort (less pregnancy, less disease) than it would have been without the sex education. (As a bit of evidence that sex ed does not cause an increase in sexual activity, a recent study sponsored by the Kaiser Family Foundation looked at 23 school-based sex education programs and found "No indication that school-based sex education encourages 15- to 19-year-olds to experiment with sex," *USA Today*, 24th January, 1994, p. 10).

Rush on Crime and Punishment

With Chairs and Chambers for All

<div style="text-align: right">**7**</div>

The reasoning in this chapter concerns crime and punishment, topics of immense interest (and intense heat) for most Americans. Rush takes what is often called a 'tough' line in this area. As we shall see, the problem is not that Rush's views on crime and punishment are wrong or incapable of reasonable defense; rather, it is that his ARGUMENTS *for those views are often* FALLACIOUS.

Rushing the ACLU

Our first example concerns capital punishment in the case of convicted murderer Robert Harris.

> One of the arguments against execution was
> that Harris had been the victim of fetal alcohol
> syndrome, of an alcoholic mother who drank while
> she was pregnant with him. Now, wait a minute
> here. Who do you think made this argument? The
> ACLU. And who was it that argued before the U.S.
> Supreme Court that the standards of Roe v. Wade
> should not be changed to accommodate the
> Pennsylvania law restricting abortion? The ACLU.
> Their position is that the fetus in the womb is not a
> human life at all, just an inanimate mass of tissue.
> But in the case of Robert Alton Harris, the same
> people say that when he was in the womb, he
> was a person with a brain that was damaged by
> his mother's drinking. That's right—a foolish
> consistency is the hobgoblin of little minds.
>
> (*The Way Things Ought To Be*, pp. 176–77)

In the above passage, Rush is trying to rebut the ACLU's ARGU-
MENT against executing Harris. In purporting to carry out that task,
he observes that the ACLU has taken a position on the legal status
of the fetus which is inconsistent with its earlier position in defense
of *Roe v. Wade*. The reasoning can be represented as a complex
ARGUMENT:

**(1) The ACLU argues that Harris should not be executed
because his brain was damaged by his mother's drinking
when he was a person in his mother's womb.**

131

But the ACLU said in *Roe v. Wade* that the fetus is not a human life (person) at all.
↓ The ACLU is inconsistent.
↓ The ACLU's ARGUMENT against Harris's execution is flawed. (Implied)

There are several FALLACIES here. First, Rush's reference to the ACLU's position on the status of the fetus in *Roe v. Wade* is strictly irrelevant to, even if inconsistent with, the COGENCY of their current ARGUMENT against Harris' execution. The point, even if true, is wholly AD HOMINEM—it is an irrelevant attack on the argu*er* (the ACLU), when it should be dealing with their ARGUMENT. The real question at issue is 'Is their current ARGUMENT COGENT?', not 'Is it consistent with what they said in some other case?' (See Chapter 2, page 30, on ARGUMENTUM AD HOMINEM.)

Allow me to expand on the above point since it seems to fly in the face of common sense. There are situations when it is clearly relevant to point out inconsistencies. Indeed, in Chapter 2 we specifically recognized inconsistency as a FALLACY. But the FALLACY there referred to inconsistency *within an* ARGUMENT. The inconsistency that Rush has alleged is not within the ACLU ARGUMENT in the Harris case; it's an inconsistency between that case and some other ACLU case. Assuming the inconsistency, Rush would be correct if his point were merely that the ACLU could not be right in both cases. But that's not his intent; he's arguing that the ACLU is wrong in the Harris case. But *that* CONCLUSION does not follow from the (alleged) ACLU inconsistency between the two cases. What this means is that:

(2) The ACLU is inconsistent (between the Harris case and *Roe v. Wade*).
↓ The ACLU's ARGUMENT against Harris's execution is flawed.

is INVALID. It's a NON SEQUITUR: the CONCLUSION of (2) does not follow from the PREMISS.

Often we correctly take a person's change of mind on serious issues as a kind of inconsistency. Sometimes, when this change of mind is especially self-serving, we properly take this as a mark of insincerity and even dishonesty, and such people are rightly judged to give

unreliable *testimony*. But the main point stands. Their ARGUMENTS must be appraised for their own sakes. After all, even a scoundrel can produce a COGENT ARGUMENT.

Also notice that the original reasoning could be viewed as an instance of the FALLACY of IRRELEVANT CONCLUSION. (See Chapter 2, page 31) On this view, the logical flaw would consist in arguing for the wrong CONCLUSION; that is, in arguing merely for the inconsistency of the ACLU when what he needs to establish is that the ACLU's ARGUMENT in the Harris case is flawed.

But is the ACLU really inconsistent as alleged? On this important point, I'm afraid Rush is wrong. (I know. It doesn't happen often, only about 2.1 percent of the time. But on those rare occasions when it does, it's usually a Lulu.) Rush is factually mistaken in his characterization of the ACLU's position in the Harris case. They did not hold that Harris, as a fetus, was a brain-damaged person. Rather, they held that Harris, as a fetus, had suffered permanent brain damage which affected his behavior and judgment after birth. That point, whether true or false, can be made without ascribing personhood to the fetus. In mischaracterizing his opponent's position (in a way that makes it easily refutable), Rush has committed a species of the QUESTIONABLE PREMISS FALLACY known as STRAW MAN (see Chapter 2, page 39).

Finally, as a result of mischaracterizing his opponent's position, Rush has wrongly charged the ACLU with the FALLACY OF INCONSISTENCY. This means that he also commits what some logicians recognize as a separate FALLACY, the FALLACY OF FALSE CHARGE OF FALLACY.

Rushing the Execution

Here's another similar example involving the same capital punishment case.

> Then came, in my opinion, the most bizarre
> challenge [to Harris's execution] of all: the argument
> that the use of the gas chamber as the method of
> execution itself constituted cruel and unusual
> punishment, because the condemned man may
> take a few minutes to die. The obvious question is:
> Why wasn't this taken up a month before, two
> months before, or fourteen years ago? These last-
> minute appeals were designed to keep delaying
> the execution by bringing up new issues.
> (*The Way Things Ought To Be*, p. 178)

In the above passage Rush is apparently concerned to discredit the "most bizarre challenge of all": the ARGUMENT that the gas chamber is cruel and unusual punishment. And he proceeds to make the point (actually he *argues* for it) that the ARGUMENT (appeal) is intended as a delaying tactic. So his reasoning is really complex: he implies that the appeal/ARGUMENT is somehow defective because the appeal/ARGUMENT was intended as a delaying tactic. And this is so because it wasn't presented earlier. There are two interconnected ARGUMENTS in this passage:

(1) **If an appeal/ARGUMENT is not made early in a case, it is designed as a delaying tactic.**
This appeal/ARGUMENT was not made early.
↓ **This appeal/ARGUMENT is designed as a delaying tactic.**
↓ **This appeal/ARGUMENT is without merit. (Implied)**

The first ARGUMENT in the complex is COGENT, at least I see no reason to question it. It's very likely that in the Harris case, these and

134

other "last-minute" appeals were made with little hope that the execution would be permanently arrested. Still, *dum vita est, spes est* ('while there's life there's hope'), as they say.

But what about the second ARGUMENT? Clearly it's a NON SEQUITUR. The fact that the appeal/ARGUMENT was used as a delaying tactic doesn't mean that it was without merit, even if its proponents had little hope that it would convince the court.

Specifically, Rush attacks the motives of the arguer instead of the merit of the ARGUMENT. This sort of attack which is irrelevant to the real point at issue (the merit of the ARGUMENT) is called an AD HOMINEM FALLACY (see Chapter 2, page 30).

In addition, Rush seems to be guilty of implicitly confusing two very different ways in which a legal appeal/ARGUMENT can have merit. In one sense, the sense that is at issue, an appeal/ARGUMENT has merit if it is COGENT legal reasoning. Such reasoning would be worthy of acceptance by the court. In another, and very different sense, an appeal/ARGUMENT has merit if it is ultimately effective in persuading the court. Obviously an appeal/ARGUMENT can be worthy of acceptance even if it fails to persuade the court (and even if it is designed merely as a delaying tactic). In the original passage Rush may be confusing the true statement that the appeal/ARGUMENT lacked merit (effectiveness) with the unestablished statement that it lacked merit (worthiness of acceptance). If this is what Rush is doing then he is also committing the FALLACY OF EQUIVOCATION (see Chapter 2, page 34).

This possibility that Rush my be confusing two different things also suggests another way of looking at the main error in the original passage. One could say that although Rush is required to show that the appeal/ARGUMENT is itself "bizarre" or otherwise defective, he actually argues that it was an ineffective delaying tactic. From this point of view, Rush argues (albeit COGENTLY) for the wrong CONCLUSION. We call this the fallacy of IRRELEVANT CONCLUSION. (See Chapter 2, page 31.)

Poverty: A Poor Explanation

Rush continues his critique of bad liberal thinking on crime. Here he attempts to debunk some liberal explanations for recent crime.

> Of course, liberals will argue that these actions [contemporary youth crime] can be laid at the foot of socioeconomic inequities, or poverty. However, the Great Depression caused a level of poverty unknown to exist in America today, and yet I have been unable to find any accounts of crime waves sweeping our large cities. Let the liberals chew on that.
>
> (*See, I Told You So*, p. 83)

In this passage Rush attempts to refute the liberal claim that poverty causes crime. (He has a more direct 'proof' in the next citation.) He does this by pointing out that if the liberal claim were true, one would expect to find evidence of much crime during the Great Depression, a time of widespread poverty. (Presumably, he means a crime increase in rough proportion to the poverty increase.) But he finds no such evidence. Therefore, the liberal claim must be false. The main ARGUMENT looks like this:

(1) If (as the liberals say) poverty causes crime, then there would be (have been) a big crime increase during the Great Depression.
But there was not a big crime increase during the Great Depression.
↓ The liberals are wrong: poverty does not cause crime.

ARGUMENT (1) is VALID. No question about it. It has a form officially known as MODUS TOLLENS. (It's Latin. Don't worry about what it means. It's simply a name for the form of ARGUMENT displayed in (1).) But are the PREMISSES warranted?

The first PREMISS seems reasonable. Generally speaking, most liberals probably would say that poverty does cause crime (provided we don't attribute to them much more than the not very precise statement that poverty is an important factor in crime); and they probably would say that where there is more poverty there tends to be more crime. (It would be something of a STRAW MAN to attribute to them the view that all increases in poverty always result in increases in crime.) And it does seem true that if poverty causes crime one should expect to see an increase in crime during the Great Depression roughly in proportion to the increase in poverty. Of course, if there were something unusual about the Great Depression that cancelled the usual criminal effects of poverty (for instance, if the criminal effect was thwarted by massive government assistance and public works projects), the absence of an increase in crime need not be taken as evidence against the truth of the claim that poverty causes crime. With these provisos, we can accept Rush's first PREMISS in (1).

But what about the second PREMISS? Is it true that crime did not increase during the Great Depression? Rush doesn't exactly say that it didn't. He says that he has been unable to find any evidence that it did. There is an implicit bit of reasoning here:

(2) I have not found evidence of a crime increase.
↓ There was no crime increase.

Now this little argument looks very much like our old friend the ARGUMENT FROM IGNORANCE. Generally, it is FALLACIOUS to infer that something is false (or true) just because you have no evidence that it is true (or false). Wisdom generally requires that we withhold judgement pending the arrival of more evidence. Remember The Pill? (There are exceptions. Remember Rush's refrigerator? See Chapter 2, pages 26–29.)

It turns out that there is a very good reason which may explain why Rush was not able to uncover evidence of a crime increase. Prior to 1933 the government didn't collect national statistics on crime. (See *The History of Violence in America,* edited by Graham and Gurr, Bantam Books, 1969, p. 491.) That meant that if there was a big increase in crime in the four years following the stock market crash of 1929, it might be very difficult to obtain evidence of it.

In fairness to Rush, it is generally believed, although the evidence is incomplete, that crime reached a peak in the (relatively prosperous) 1920s and began to decline in the 1930s.

However, one important component of crime—the homicide rate—is known to have risen steadily for the first few years of the Depression. This statistic peaked in 1933, just about the same time that the Prohibition Amendment (the nineteenth) was repealed. And this suggests yet another reason why the crime rate may have failed to rise during the 1930s: Prohibition, which is known to have generated a lot of crime (just as drug prohibition does today), ended with the ratification of the Twenty-first Amendment (December 5th, 1933). Rush omits that relevant bit of information.

This means that the fact that crime did not increase during the Depression, if it is a fact, need not be taken as good evidence that poverty does not cause crime. And this means that Rush seems to have a HASTY CONCLUSION (NON SEQUITUR) owing in part to OMITTED EVIDENCE (see Chapter 2, pages 36 and 43).

Conclusive Proof

One of Rush's hugest howlers is his 'proof' of the absence of a causal connection between poverty and crime.

> Let me posit two facts that prove conclusively that there is no direct causal connection between poverty and crime: 1) Most poor people never resort to crime; and 2) even some wealthy people commit evil acts to enrich themselves further.
>
> (*See, I Told You So*, p. 282)

The reasoning here is straightforward: two PREMISSES and a CONCLUSION:

(1) Most poor people don't commit crimes.
Some rich people do
↓ **Poverty doesn't directly cause crime.**

Whatever the connection between poverty and crime may be, Rush's 'proof' is a NON SEQUITUR. We can illustrate the problem with Rush's little 'proof' by using an analogous proof of our own:

(2) Most people with bullet wounds don't die.
Some people without bullet wounds do die.
↓ **Bullet wounds are not a direct cause of death.**

Argument (2) has true PREMISSES leading to a false conclusion. Obviously something is wrong with (2), and (2) looks a lot like (1).

But Rush might insist that in his proof he only means to deny a *direct* causation between poverty and crime. It's not clear exactly what Rush means by 'direct' in this case. But it seems to mean at least that crime does not *invariably* follow poverty. That, of course, is true in the case of poverty and crime. And it is also true in the case of bullet wounds and death, or, to take another example, cigarette smoking and lung cancer. The causal connection in these cases is not 'direct' in Rush's sense either.

But this kind of connection, whatever we choose to call it, is precisely what is meant when social scientists ask whether social factors (like poverty and crime) are causally related, for example, when they ask if poverty 'causes' crime. So Rush may be right that the connection is not direct in his sense. But this is not the sense that is (or should be) intended when people ask about the connection between poverty and crime. Thus, Rush is apparently attempting to refute a view (that poverty **'directly'** causes crime) that no one—at least no liberal social scientist—holds. This makes his 'proof' an instance of the STRAW MAN FALLACY, the FALLACY of misrepresenting an opponent's position in order to make it easier to refute.

But he has not only mischaracterized the opponents' view, he has also established the wrong CONCLUSION. For the CONCLUSION that he establishes is that there is no 'direct' (invariable) causal connection between poverty and crime; what he needs to establish is that there is no genuine causal connection (of the sort known to hold between bullet wounds and death or between cigarette smoking and lung cancer) between poverty and crime. In short Rush's CONCLUSION is uninteresting and irrelevant to what he needs to establish. This is the FALLACY OF IRRELEVANT CONCLUSION (see Chapter 2, page 31).

Nobody to Blame but Liberals

Crime is bad enough. But Rush believes the problem is compounded by an alleged liberal unwillingness to assign responsibility for criminal actions. Here's Rush reasoning about crime and liberal responsibility:

> Why does such a crime happen? [referring to a report of a frustrated employee shooting his boss] Is it because of the guy who pulled the trigger? Noooo! With liberals, there are always deeper, root causes. The wrongdoer is never responsible . . . for his act. [A guest expert on 'Good Morning America'] suggested that the crime might have been provoked by the boss's "insensitivity". In other words, some bosses deserve to die.
>
> (*See, I Told You So*, p. 223)

Rush seems to be taking the liberal guest expert as typical of liberal thinking on crime. He argues from the fact that this liberal seems to think that the employee who shot his boss was provoked by his boss's insensitivity to the conclusion that he thinks that killing the boss was justified. And he uses that conclusion to establish the more general point that liberals think wrongdoers are never responsible. Here's how we could represent the essential reasoning.

(1) Liberals believe that the employee who shot his boss was provoked by his boss's insensitivity.
↓ **They believe that some bosses deserve to die.**
↓ **They believe that wrongdoers are never responsible.**

Both inferences seem to be NON SEQUITURS (from the Latin, 'does not follow'); in neither inference does the CONCLUSION follow from the PREMISS. It's possible, of course, that Rush is assuming, as unexpressed PREMISSES, certain statements that would make the reasoning VALID in each ARGUMENT. But the PREMISSES required are most implausible.

Let's take the first inference. If that ARGUMENT is to be VALID, Rush would need to assume (as an unexpressed PREMISS) that liberals believe that provokers of homicides deserve to die. If we add the unexpressed PREMISS, the argument would look like:

(2) Liberals believe that the employee who shot his boss was provoked by his boss's insensitivity.
Liberals believe that provokers of homicides deserve to die. (Unexpressed PREMISS)
↓ Liberals believe that some bosses deserve to die.

The second PREMISS in (2) seems false (and it doesn't improve its plausibility to qualify the claim by saying that liberals merely believe that those bosses who provoke homicide through insensitivity deserve to die).

Let's look at the second inference in (1). One thing that is needed to make the reasoning VALID is a logical connection between the killing being deserved and the killer not being responsible. That's easily done:

(3) Liberals believe that some bosses deserve to die.
Liberals believe that those who do things that are deserved are not responsible for doing wrong. (Unexpressed PREMISS)
↓ Liberals believe that some boss-killers are not responsible.

This ARGUMENT is VALID, but we don't yet have the main CONCLUSION—the second CONCLUSION in (1). I think we can already see that the CONCLUSION that we need to establish (Liberals believe that wrongdoers are never responsible) is a generalization far beyond the reach of the evidence that Rush's boss-killer example can provide. If we are to have a VALID ARGUMENT for that very general CONCLUSION, we shall need a whopper of a generality for an unexpressed PREMISS.

(4) Liberals believe that some boss-killers are not responsible.
Liberals believe that all wrongdoers are blameless like the boss-killer. (Unexpressed PREMISS)
↓ **Liberals believe that wrongdoers are never responsible.**

ARGUMENT (4) is VALID; its CONCLUSION does follow from its PRE-MISSES. But the second PREMISS is hardly warranted. It's just not true that all (or most) liberals harbor this belief. (Indeed, this belief is inconsistent with the belief mentioned in the first PREMISS of (3). For if wrongdoers generally are not responsible, then provokers of homicides are not responsible, and so, hardly deserve to die. The inconsistency, however, is not Rush's; it's an inconsistency within the liberals' beliefs—as those beliefs are characterized by Rush. But, to the extent that Rush mischaracterizes those beliefs in order to make the liberals' position more easily refutable, he is guilty of the STRAW MAN FALLACY. See Chapter 2, page 39.)

One last point about this example. It's possible that the second CONCLUSION in (1) may not really be intended by Rush as a CONCLUSION; it may be merely a PREMISS. But as such it is highly questionable. Rush seems to fail to grasp the point that accountability is often a matter of degree and that there may be mitigating circumstances, including provocation, which can affect our assessment of a person's culpability without rendering that person completely blameless.

Rush on the Liberal Media

8

The Truth About Murphy Brown and Other Fictions

Rush Limbaugh has long been suspicious of the media, which he often calls 'the liberal media' because he believes that they serve the interests of, and are largely controlled by, liberals. This is a point of view which easily lends itself to conspiratorial theories which are notoriously hard to prove or disprove. Fortunately we need not take a position on the truth or falsehood of Rush's many opinions on the political predilections of the media, or indeed, whether 'they' have any predilections. Rather, our task, as usual, is to draw out Rush's ARGUMENTS for his opinions and to assess the COGENCY of those arguments.

Murphy Brown: The Wrong Message

Our first example concerns the media and family values. Rush tries to convince us that, on the 'Murphy Brown' flap, Dan Quayle was right, or at least his critics (the "dominant media culture") were wrong.

> Recall the controversy surrounding the 1992 season finale of the CBS sitcom 'Murphy Brown' [whose main character gave birth out of wedlock]. A day later, Vice President Dan Quayle denounced the episode, saying it sent the wrong message. . . . Naturally he was savaged by the dominant media culture . . . who complained that it was only a TV show with fictional characters and therefore had no message. Well, how can that be? Aren't these the same people who admit using their TV shows to get their message across . . . ? Aren't they the same people who complain about the portrayal of upwardly mobile blacks on TV . . . because such portrayal sends the wrong message about the black condition in America today? How, if there is no influence? . . . No, Quayle was right on the money.
>
> (*The Way Things Ought To Be*, pp. 187–88)

Rush seems to be defending Quayle by attacking Quayle's critics ("the dominant media culture"). The reasoning seems to be that Quayle is correct because his critics reveal an inconsistency on the very point that they criticize Quayle for. The reasoning could be represented as a complex of two arguments:

146

(1) Dan Quayle's criticism of 'Murphy Brown' for sending the 'wrong message' was savaged by the media who say that fictional TV has no message.
But these media critics have said (in other contexts) that fictional TV does have a message.
↓ The media critics contradict themselves. (Implied)
↓ Quayle's criticism is right.

I think Rush's implication that the media are inconsistent in their criticism of Quayle is correct, and his first ARGUMENT does seem CO-GENT. But what about the second ARGUMENT? Its CONCLUSION (that Quayle is right) obviously doesn't follow from the PREMISS (that the critics contradict themselves). It doesn't even strictly follow from the PREMISS that the media critics are wrong when they say that fictional TV has no message. The only CONCLUSION that we can properly draw from their contradictory opinions about TV messages (that fictional TV does, and does not, have a message) is that one is false and one is true. But we can't tell which one is true and which one is false (even though the media, before the Murphy Brown flap, had spoken and acted as if they believed that fictional TV *does* have a message).

So we can't tell, from the fact of the inconsistency of the media beliefs about TV messages, which belief is true. But notice an important point here. Even if we could tell, even if we knew that fictional TV did have a message, it still would not follow that Murphy Brown was sending the 'wrong' message as Dan Quayle claimed.

I think we have to conclude that Rush's second ARGUMENT in (1) is essentially AD HOMINEM. It's an attack on the arguer (the media) rather than on the ARGUMENT (the media's criticism of Quayle's criticism of Murphy Brown). And Rush's attack, though true (the media critics apparently did contradict themselves), is irrelevant to the main point at issue (whether Quayle was right). See Chapter 2, page 30.

We can offer some useful suggestions about what Rush might have done instead. The AD HOMINEM attack can stay. It is useful to point out inconsistencies in our opponent's positions. (See Rush's attack on the ACLU for its alleged inconsistency, in Chapter 7, pages 131–33) After all, inconsistencies like the one Rush discovered can suggest all kinds of interesting things about those who make them, including

dishonesty, insincerity, or a general carelessness in one's thinking processes. (Of course, some such inconsistencies can merely mean that a person has changed his/her mind to accommodate a change in reality. The philosopher Bertrand Russell advocated threatening the Soviets with nuclear war before 1949; but he advocated peaceful coexistence after 1949. An apparent inconsistency which is explained by the fact that an important aspect of reality had changed in 1949—the Soviets obtained nuclear weapons.)

But Rush frequently makes the mistake, as he does here, of trying to get too much mileage out of the inconsistency. He would have done better to have tackled the main issue and argued directly in defense of Quayle's position. To this end it would be useful to provide evidence that: 1. Murphy Brown was indeed 'sending' this message in a way that was likely to have a harmful effect on the American society; 2. this harmful effect would outweigh any other beneficial effects that the message might cause (such as discouragement of abortion or empowerment of women); and 3. Quayle's implied recommendation that TV should become more morally responsible about its 'messages', and presumably more self-censoring, would not, if followed, lead to a deterioration in the quality of art and the freedom of its expression.

The issue requires an answer to these questions, at least. Perhaps Rush could provide good evidence on these points. But in the original passage he doesn't do it, or even suggest that these points are relevant.

Bad Logic is Bad News

A theme which recurs in much of Rush's writing concerns the media and their manipulation of the truth to suit their liberal agenda. During the years of the Bush presidency this often allegedly took the form of exaggerating the weakness of the economy. Here's Rush criticizing the media for its perennial exaggeration of the financial difficulties of American shoppers.

> Every year they [the media] go out and do the same story. They report the American people aren't spending as much, that 'this year they're not wasting money'. Well, excuse me. The American people never waste money no one I know goes in and throws money around. 'Americans are shopping more carefully these days,' the news media tell us. The reason they are doing that is because we've been in the deepest recession in years.
>
> (*The Way Things Ought To Be*, p. 45)

One bit of reasoning seems clear enough. Rush is trying to convince the reader that the media are mistaken when they report "every year" that "this year the American people are not wasting money" (a statement which he correctly takes to imply that Americans have wasted money in the past). And he gives as his reason the statement that the American people never waste money. The ARGUMENT looks like this:

(1) Every year the media say that the American people are not wasting money this year (implying that they have in the recent past).
The American people never waste money.
↓ The media are wrong. (Implied)

A Newtmare

On a straightforward, and not very charitable, reading, (1) seems to suffer from at least one QUESTIONABLE PREMISS. It's very doubtful whether the American people never (haven't and don't) waste money. It's a generalization in need of support, as Rush seems to realize when he appeals to his own personal experience as evidence:

(2) No one I know wastes money ("throws money around").
↓ The American people never waste money.

But (2) seems to be INVALID in addition to having a QUESTIONABLE PREMISS. For one thing, it tries to support a generalization about American shoppers on the basis of Rush's limited experience (he knows only a tiny percentage of Americans and his experience extends only a few decades into the past. This makes (2) very likely a FALLACY OF HASTY GENERALIZATION (see Chapter 2, page 34).

It also seems to be an ARGUMENT FROM IGNORANCE because it concludes that Americans don't waste money on the basis of a lack of evidence that they do. Sometimes such inferences are COGENT, for example, in the case of Rush and his refrigerator (see Chapter 2, page 29). But in the present case, it is as if the refrigerator had a million shelves and Rush merely looked at a hundred. (I know Rush wishes his refrigerator had a million shelves, but that's irrelevant.)

But perhaps there is a more reasonable way to interpret Rush's reasoning in the original passage. Take his PREMISS in (1) about American spending habits. Perhaps he merely means that *most* Americans don't (almost never) waste money. Presumably, the (alleged) media's claim about Americans is only meant to apply to most, not all, Americans. So, all Rush needs to establish to prove them wrong is that *most* Americans don't waste money. Here's the reasoning that Rush needs to defend:

(3) Every year the media say that (most) Americans are not wasting money this year (implying that they have in the recent past). But (most) Americans don't (almost never) waste money.
↓ The media are wrong.

This argument is easier to defend, because the second PREMISS is more likely to be true than in (1). But it is still a generalization

which can be reasonably doubted and, so, stands in need of support. But Rush's appeal to his own experience is now a stronger bit of reasoning:

(4) I don't know any Americans who waste money.
↓ Most Americans don't waste money.

This ARGUMENT looks pretty good from the perspective of logical correctness: the PREMISS does seem to provide a fair degree of support for the CONCLUSION. Still, there is a potential problem: the riskiness of generalizing (even a limited generalization about the majority of Americans) on the basis of limited experience. Only if Rush's personal knowledge includes a group of people who are fairly representative of American shoppers can (4) be COGENT. If Rush's experience is very small compared to the American population, and if his knowledge is not representative, (4) would commit the FALLACY OF HASTY GENERALIZATION (see Chapter 2, page 34).

Let's assume his knowledge of American shoppers is representative. In that case we should expect an instance of a money-wasting shopper to turn up in Rush's experience if indeed a significant portion of Americans were money-wasters. The fact that, according to Rush, none has, is a pretty good reason for saying that most do not waste money.

But is the PREMISS of (4) warranted? This depends on what Rush understands by "wastes money". Actually, Rush says "throws money around" in the original passage when he offers support for his generalization. To be quite accurate, ARGUMENT (4) should be represented as:

(5) No one I know throws money around.
↓ Most Americans don't waste money.

The logical correctness (VALIDITY) of this ARGUMENT is OK provided the PREMISS will take us to the CONCLUSION. A natural way to do that is through the PREMISS of (4). That is, Rush may intend the PREMISS of (5) to imply the PREMISS of (4), as it would if "throws money around" means the same as "wastes money". So we have a complex of two arguments (I know this is getting complicated, but we're doing

logic, for Heaven's sake; it's the way things *are*, not the way they *ought to be*; and besides, I told you so):

(6) No one I know throws money around.
↓ No one I know wastes money.
↓ Most Americans don't waste money.

Let's look at the first argument in (6)

(7) No one I know throws money around.
↓ No one I know wastes money.

The second ARGUMENT of (6) can't be COGENT unless (7) is. Is (7) COGENT?

Let's look first at VALIDITY. We need the right sort of connection between "throws money around" and "wastes money". Obviously if Rush is using the two expressions to mean the same thing, then the ARGUMENT is VALID. (A statement implies itself and its synonyms, of course.)

We can't be sure just how Rush is using these terms. They are somewhat vague. In (2) we charitably assumed that he was using them synonymously. But there is a potential problem here. As Rush himself is fond of saying, "Words mean things." That is, words have meanings that are fixed more or less independently of our wishes, and if our talk is not to degenerate into subjective twaddle, we must use words within the boundaries of their ordinary meanings.

The problem for Rush's reasoning is that the terms 'waste money' and 'throw money around' seem to have different meanings. Ordinarily, we speak of 'wasting money' when somebody (usually somebody *else*) spends money on something they don't need or won't benefit from. Whereas we speak of 'throwing money around' when somebody (usually somebody *else*), often somebody with lots of money, spends it lavishly (in excess of what is appropriate) and often in a way intended to show off. In these ordinary senses, **'throwing money around' does imply 'wasting money', but 'wasting money' does not necessarily imply 'throwing money around'**; we might say that for many years Rush wasted his money on cigarettes without necessarily implying that he was thereby throwing any money around.

('What a nitpicker,' I can hear some dittoheads protesting. But hang on, there's an important logical lesson here which we ignore at our peril.)

If this is correct, we can say that if somebody throws money around, he/she wastes money. But it won't generally be true that if they waste money they throw money around. This means that if we know somebody who throws money around, we thereby know somebody (the same person) who wastes money.

Now let's apply this to question the VALIDITY of (7). Taking the terms in their ordinary sense, the ARGUMENT comes to this (when we add a PREMISS stating the ordinary connection between the two ideas):

(8) **If Rush knows a person who throws money around, Rush knows a person who wastes money. (Unexpressed PREMISS)**
Rush does not know a person who throws money around.
↓ Rush does not know a person who wastes money.

But (8) is not VALID. The FALLACY is a variation of a FORMAL FALLACY known as the FALLACY OF DENYING THE ANTECEDENT. (See Chapter 2.) The form of the reasoning is defective, and ARGUMENT (8) is no better than our fallacious example in Chapter 2, page 26:

(9) **If Rush wrote *The Firm*, then he is a popular author.**
Rush did not write *The Firm*.
↓ Rush is not a popular author.

In addition to VALIDITY problems, (8) apparently has an UNWARRANTED PREMISS ("Rush does not know any person who throws money around.") But if the term 'throwing money around' is being used in its ordinary sense, it's a near certainty that Rush knows such people.

Of course, terms like 'excessive' and 'lavish' have subjective standards, and it is possible that Rush is using 'throws money around', and 'wastes money', in senses so special that not even Daddy Warbucks can be said to have done it. Such a private definition of these terms would make complex ARGUMENT (6) COGENT.

Unfortunately, such word usage wouldn't be acceptable. Remember the point of the original passage. (I know that was a long time ago, but try to recall anyway.) Rush is trying to provide an example of

the folly of the media by showing that the media's claim about Americans 'wasting money' is wrong. And to do this *it is absolutely essential that he use that term in the same sense that they do in their original claim.* To do otherwise is to commit the FALLACY OF STRAW MAN, that's to say: the FALLACY of misinterpreting your opponent's position for the purpose of making that position easier to refute (see Chapter 2, page 39).

For example, if the media don't mean by 'wasting money' the extremely rare sort of super excesses that Rush seems to have in mind, then Rush stands accused of the STRAW MAN FALLACY (or possibly the FALLACY OF EQUIVOCATION, by which the arguer uses the same word or phrase in more than one sense in the same ARGUMENT).

Well, what *do* the media mean by their alleged remark about Americans not 'wasting money'? Rush's last two sentences provide a hint. Notice that he is agreeing with the media claim that Americans are "shopping more carefully these days." This need not be taken as a contradiction on Rush's part. The fact that people are shopping more carefully this year does not necessarily imply that they were wasting money last year. But since the media did say that the American people are "shopping more carefully these days", and Rush quotes the statement in agreement, it's just possible that the alleged media quote about 'not wasting money' may simply be intended by the writer(s) to mean 'shopping more carefully'? At least that's not an unreasonable interpretation. And in the absence of evidence to the contrary, the PRINCIPLE OF CHARITY would certainly suggest such an interpretation.

So, in addition to the FALLACIES already mentioned, Rush may be being unduly uncharitable in his reading of 'not wasting money'. Of course a transgression of the PRINCIPLE OF CHARITY is not strictly a FALLACY, but it is a kind of logical peccadillo (translation for dittoheads: a minor wrongdoing) nonetheless, especially in this case, if it led him to make a STRAW MAN ARGUMENT against the media. (I think I can hear the dittoheads objecting here, and paraphrasing a famous conservative in Rush's defense: 'Uncharity in the defense of conservatism is no vice.' Personally I don't think that defense will hold water. Let's bury it.)

The lessons in this example seem clear enough. In the end it looks as though Rush has made much ado about nothing. And, worse, in the course of so doing, he has displayed some sloppy logic. Not that the media don't exaggerate and hype their stories. There's little question that they do. But Rush's example fails to show this effectively. If he wants to establish that some kind of hype is typical of the media, he needs to establish a well-documented pattern of several media sources over time. But he—and the rest of us—would do well to remember that one should refrain from glib generalizations about diverse groups ('the media', 'the American people'). And when one must generalize, be as precise as possible and be ready to support those generalizations with adequate data. And "adequate data" usually means more than an appeal to your own limited experience. And, oh yes, don't forget that "words mean things."

It Takes One to Know One

Mindful of the media's criticism of alleged corporate greed in the 1980s, Rush makes his response.

> Recall the Decade of Greed? The media have drilled it into the American psyche that the 1980s represent a shameful epoch in our history because of the relentless and blind pursuit of profit But yet, some of the very people who decried the Decade of Greed are displaying symptoms of greed themselves.
>
> (*See, I Told You So,* pp. 223–24)

In this passage Rush is trying to discredit the media criticism of the 1980s as a decade of greed by citing the supposed fact that the media people who made the criticism are greedy themselves. The reasoning may be represented as:

(1) The media claimed the 1980s were a decade of greed.
 But the media are themselves greedy.
 ↓ We may dismiss their claim. (Implied)

It's not quite clear whether Rush intends the discreditation to stem from the media's greed, or its hypocrisy. The fact that the examples of 'greed' that he cites (see next citation) are merely the sorts of ordinary corporate mergers and buy-outs that he otherwise reckons as part of the way things ought to be (they are a normal feature of the market system) suggests that it's the hypocrisy that discredits the media's criticisms of corporate greed. If so, his original argument may best be represented as a complex of two ARGUMENTS:

(2) The media claimed the 1980s were a decade of greed.
 The media are themselves greedy.
 ↓ The media are hypocrites.

↓ We may dismiss their criticism of the 1980s.

Let's grant the COGENCY of the first ARGUMENT. If the PREMISSES are true, the media do not practice what they preach and are, indeed, hypocrites. But what about the second CONCLUSION?

Whether the media are hypocrites or not seems barely relevant to the question of whether their criticism of corporate capitalism in the 1980s is accurate. Indeed, one might take the tack that Rush's charge of media greed, if true, puts the media in a special position of knowledge on the grounds that 'it takes one to know one'.

We have to conclude, I think, that Rush's attack, although true, is not directly relevant to the truth or falsity of the point at issue, namely: the media's claim that the 1980s were a decade of greed. This error, you'll recall, is the AD HOMINEM FALLACY.

Sometimes, as in this case, when the attack takes the form of defending against the charge of indulging in a dubious practice by countercharging the critic with the same or similar practice, it is known as the TU QUOQUE version of the AD HOMINEM. (TU QUOQUE is from the Latin meaning 'you're one also'.)

Media Greed?
A Complex Question

Here's a continuation of the greedy media theme. In this passage Rush includes some examples of their greed.

> The New York Times, one of the nation's principal critics of the 1980s, spent $1.07 billion in 1993 to buy the Boston Globe. . . . why do the owners of the New York Times want another paper? . . . Is there not a homeless problem in New York and Boston? Why couldn't the New York Times just have come in and handed these unfortunate folks some money? Why not send in that money to retire some of the federal deficit? . . . Why do liberals except themselves from the socialistic gospel they preach?
>
> (*See, I Told You So*, p. 224)

In this citation Rush is criticizing the *New York Times* for not practicing what they preach. The implied CONCLUSION is that they are hypocritical. And, considering that this passage comes immediately after the previously cited passage, Rush may be intending this example of liberal media greed as (somehow) evidence against the media charge that the 1980s were a decade of greed. We can show this as a complex of two ARGUMENTS:

(1) The liberal *New York Times* bought the *Boston Globe* instead of helping the poor.
The liberal media preach a socialistic gospel which they never apply to themselves.
People should practice what they preach. (Unexpressed PREMISS)

↓ The *New York Times* is hypocritical. (Implied)
↓ The media's charge of greed in the 1980s can be dismissed.

Let's notice immediately that the second ARGUMENT in (1) is AD HOMINEM for the reasons stated in the previous citation.

But the main error in the first ARGUMENT is QUESTIONABLE PREMISS. Rush's purported perplexity is a consequence of his own abuse of language. Liberalism is not the same as socialism. Liberals generally believe in, and practice, profit-seeking capitalism. Certainly the *New York Times* does. Liberal critics of The Decade of Greed don't generally criticize that decade merely because people pursued profits, but because some of them sought profits *excessively* and failed to redistribute an adequate portion of those profits for the public good. In other words, liberals aren't against business and profits *per se*. They're against what they see as excessive profits and unfair practices which benefit only a privileged few.

Also, notice the COMPLEX QUESTION in Rush's last question. (This is not *per se* a logical FALLACY, but it is often a source of falsehood and confusion.) The proper retort, of course, is: *Do* liberals (some? all?) preach a socialistic gospel? And *do* they always exempt themselves from it? The request for an explanation of these alleged phenomena ('why?') presupposes that the answer to both is 'yes'—a dubious assumption (see Chapter 2, page 41).

We might add that in the original passage, it is possible that Rush is offering the *New York Times* example as his evidence for the PREMISS that the liberals *always* exempt themselves from their socialistic gospel. If that is indeed his intent, then he commits the FALLACY OF HASTY GENERALIZATION as well. One case doesn't provide much support for the general claim (see Chapter 2, page 34).

It's more likely (and more charitable of us to say) that he intends his example merely to *illustrate* rather than *prove* the general statement about liberals. So there would be no FALLACY OF HASTY GENERALIZATION. But it remains an unwarranted generalization which, as we noted above, constitutes a QUESTIONABLE PREMISS FALLACY.

Rush and Liberal Deceptions

9

Idiots, Liars, Megalomaniacs, and Other Nice Guys

In this chapter we find a wide assortment of logical errors in Rush's reasoning against the liberal community. His pronouncements and ARGUMENTS concern issues in Reaganomics, health care, discrimination, and public education. His errors include his usual transgressions in the regions of the general FALLACIES of VALIDITY and UNWARRANTED PREMISS. But the first two examples provide nice illustrations of Rush's well-developed penchant for FALLACIES OF OMITTED EVIDENCE as well.

Some Were Not Trickled On (under Reagan)

In Rush's second book (*See, I Told You So*), he devotes a whole chapter to economics. Specifically, he tries to defend Reaganomics against the received liberal 'wisdom' that the Reagan era saw the 'rich get richer and the poor get poorer'.

In the following passage, Rush attempts to rebut the liberal myth that the poor got hammered under Ronald Reagan.

> The percentage of families earning less than $15,000 dropped [during the Reagan years].
>
> (*See, I Told You So*, p. 113)

The reasoning here is pretty basic. Rush is citing the general statistic on income to establish the unexpressed CONCLUSION that the poor actually benefited under Reagan—or, at least they didn't do worse. The reasoning looks like this:

(1) The percentage of families earning less than $15,000 dropped [during the Reagan years, 1981–88].
↓ The poor did better (or not worse) under Reagan. (Implied)

In fairness to Rush it should be said that the above quote is only one of many statistics cited by him to disprove the liberal charge that the 1980s was a 'decade of greed' and 'the rich got richer and the poor got poorer'. But it's a useful example because it allows us to see how statistics can give a misleading picture, especially when relevant evidence is omitted.

Rush's PREMISS does seem to provide some support for his conclusion. Rush's PREMISS is true, although the drop was small—less than 1 percent. But there are a couple of preliminary points about poverty to keep in mind here. First, the families earning less than $15,000

Reagonomics and the Poor: Who's Lying?

(1990 dollars) will include some non-poor families as well, since the poverty line for a family of four in 1990 was $13,359. This means that it's *possible* that some families initially earning more than this but less than $15,000 managed to earn more than $15,000 during the Reagan years thereby making the group in question (families earning less than $15,000) a smaller percentage of all American families. And this could be done without the truly poor families experiencing any increased income. So the statistic cited by Rush does not necessarily show that the poor improved under Reagan.

Second, we don't want to confuse two technically distinct questions: Did the poor get poorer under Reagan? and Did more Americans become poor under Reagan? As regards the citation above, the most charitable interpretation of Rush's implied conclusion is that the percentage of poor Americans (families) did not increase under Reagan. And guess what? His conclusion is true under this interpretation—*provided we choose an appropriate year as a base from which to measure.* A good year would be 1983—the year that US poverty reached a fifteen year high (a bit of evidence omitted by Rush). Relative to that year, by most measures, things did improve.

But, although this is interesting, it EVADES THE ISSUE (the larger issue) of how the decade measures up by comparison to the 1970s on the issue of poverty. For example, did the percentage of the population that qualified as poor increase? This question is pretty easy to answer. Under Reagan the US attained the highest percentage of poor since the mid-1960s when Kennedy and Johnson began the 'war on poverty'—15.2 percent in 1983, up from an all-time low of 11.1 percent in 1973. From fiscal years 1982–1989, the nation averaged a 13.9 percent poverty rate. During the preceding four years (under Carter) the average was 12.2 percent. That's a difference of 1.7 percent of the population per year, or about four million people.

These facts are not mentioned by Rush, and they help us to see the sense in which it is misleading to imply that the plight of the poor did not worsen during the Reagan years.

When More is Less

Here's Rush trying to make the case that, contrary to the popular liberal view, the rich actually bore an unfair share of the tax burden.

> Despite the charge that 'the rich got richer and pay less tax . . . ,' between 1980 and 1992 the wealthy not only paid more income taxes in actual dollars, but they paid a greater share of income taxes as a percentage of their income compared to other groups.
>
> (*See, I Told You So*, p. 115)

Once again the reasoning is pretty straightforward. Rush is citing the fact that during the Reagan and Bush years, the wealthy paid more income tax dollars and a greater share of their income than other groups as evidence that it's not true that the rich paid less taxes. The reasoning may be expressed as:

(1) From 1980 to 1992 the wealthy paid more in income tax dollars and a greater share of their income than other groups.
↓ **It's not true that the rich paid less taxes under Reagan and Bush.**

The first thing that should be noticed is that Rush comes dangerously close to a STRAW MAN FALLACY here, because the critics of Reaganomics usually charge that Reagan's tax policies gave the rich unfair advantages, not necessarily that they allowed the rich to pay "less taxes", whatever that means.

But let's focus on the charge and response as Rush formulates them. We should notice that the phrase 'paid less taxes' is ambiguous. If it means 'paid a smaller number of income tax dollars', then the CONCLUSION will follow and be true if the PREMISS is. But if it means 'paid a smaller *percentage* of income as income taxes', then it does not follow and may not be true. (Indeed, Rush himself apparently

believes it would not be true since his chart on his next page shows a decrease of 9.3 percent for the wealthiest 20 percent and a decrease of 7.9 percent for the wealthiest 1 percent.)

Which interpretation of the phrase is appropriate really depends on what the critics mean when *they* charge that the rich paid less. If they mean 'less' as a percentage of total income (as most would), then Rush has not refuted *their* charge but some other, and his reasoning would be the FALLACY OF IRRELEVANT CONCLUSION (see Chapter 2, page 31).

During the Reagan years, while the top individual income tax rate on the rich was reduced from 70 percent in 1981 to 28 percent by 1988, other taxes were increased, especially social security taxes, which fell disproportionately hard on the non-rich. Also, capital gains taxes, which apply mainly to the rich, were dramatically reduced during the 1980s (from 49 percent in 1978 to 20 percent from 1981 to 1987) and thereby enabled the rich to reduce their tax burden. If we look at *all* federal taxes, it turns out that between 1977 and 1988, taxes (as a percentage of income) on the poorest ten percent increased slightly; those on the middle class stayed about the same; *but those on the richest 5 percent declined about 10 percent, and those on the richest 1 percent declined about 20 percent.* (See Kevin Phillips, *The Politics of Rich and Poor: Wealth and the American Electorate in the Reagan Aftermath*, Harper Perennial, 1991, p. 83.)

In so far as Rush fails to mention the declining *percentage* paid by the rich as well as other taxes which are relevant to the issue of taxes paid by the rich relative to other groups, he commits a FALLACY OF OMITTED EVIDENCE (see Chapter 2, page 43).

The Truth (and the Proof) About Liberal Empowerment

Here's Rush plying his psychological insights to make the case that liberals are primarily motivated by love of power.

> These people [Congressional liberals] want to create as much government dependency as possible—not because they believe it will improve the quality of lives or is in the best interest of our nation, but because it will empower <u>them</u>. For proof of this theory you need only refer to the fact that whatever liberal legislation these folks impose on our society, they invariably exempt themselves from its rules and effects.
>
> (*See, I Told You So*, p. 134)

In this passage Rush is trying to persuade us that the main motive (or could it be the *only* motive?) of Congressional liberals is to enhance their own power and not the good of the nation. The reason he cites as "proof" is that they exempt themselves from the laws they pass. The reasoning goes like this:

(1) Congress exempts itself from (many of) the laws it makes.
↓ Congress (at least the liberals in Congress) act to enhance their own power and not to improve the nation.

This is a gross NON SEQUITUR—even for Rush Limbaugh. The CONCLUSION simply does not follow from the PREMISS. His claim to be giving a "proof" suggests that he is undertaking a bit of DEDUCTIVE reasoning, in other words: that he is claiming that his PREMISS provides *complete* support for his CONCLUSION, or, to put it slightly differently, that his CONCLUSION is *necessarily* true, if the PREMISS is (see

Chapter 1). But the ARGUMENT is obviously INVALID. THE PREMISS is true, but its truth does not necessitate the truth of the CONCLUSION.

But it would be uncharitable to take Rush as intending a DEDUC-TIVE ARGUMENT in the original passage, despite his DEDUCTIVE language. What he probably intends (or should intend) is an INDUCTIVE ARGU-MENT to the effect that the PREMISS of (1) makes the CONCLUSION likely. Looked at from this point of view, (1) is an attempt to establish the most plausible explanation for what certainly *appears* to be very self-serving behavior.

But there are other at least equally plausible explanations. For example, it may be that Congress wants to enhance their power *and* improve the nation. Also, the Founding Fathers, whom few would accuse of seeking power enhancement in Rush's sense, explicitly made members of Congress 'privileged from arrest' for misdemeanors and slander (US Constitution, Article 1, Section 6). This double standard is presumably motivated by the desire for efficiency in law-making rather than love of power.

As a general point, we would all do well to remember that motives for actions are notoriously difficult to 'prove', and the best we can do in many cases is to show that the actions are at odds with the law or with the principle of fairness or equality, or that the actions have consequences which reasonable people regard as undesirable. And there's another reason why attempting to prove motives may be inappropriate. The motive, even if provable, may be of very little relevance to the point at issue. For example, you and I may differ over whether a piece of legislation is good for the nation. The fact that some of the cosponsors of the legislation may represent states that stand to benefit from the legislation, and thereby indirectly enhance their co-sponsors' power, is of little relevance to the question of the national merit of the legislation.

Health Care: Dr. Limbaugh's Foreign Policy?

The topic of health care provides Rush with an example of liberal delusion at its best (or worst?). In this passage Rush argues that the US health-care system is in good shape.

> If you have any doubts about the status of American health care, just compare it with that in the other industrialized nations. Ask anyone you know from a foreign country where they would most like to be treated if they had a medical emergency. Ask them which country is the envy of the world when it comes to health care.
>
> (*See, I Told You So*, p. 153)

In this passage Rush is pretty clearly trying to persuade his readers that the US health-care system is the best. He does this by appeal to the alleged testimony of foreigners. Here's how his reasoning may be represented:

(1) Most foreigners believe that US health care is the best.
↓ US health care is the best.

ARGUMENT (1) has several problems. First, it has a QUESTIONABLE PREMISS. Most of the West Europeans and Britons that this writer has consulted on this question have been reluctant to concede that the US system has any advantages over theirs. I can't claim that my sample of foreigners was truly representative. But even if the PREMISS is true, it would not follow that US health care is the best, because most foreigners are not appropriate authorities on health-care systems and

169

their comparative status. In other words, Rush commits the FALLACY OF APPEAL TO INAPPROPRIATE AUTHORITY (see Chapter 2, page 44).

Of course, Rush may mean merely to say that those foreigners who have studied the issue and are in a position to know, say the US system is the best. If that is true, it is certainly a relevant and strong reason for Rush's CONCLUSION. But surely this claim is questionable. Part of the problem, of course, is deciding a) what is to constitute a 'good' system, as well as b) how to assess the comparative degree of quality of different systems.

There is no doubt that many foreigners admire US medicine which has often led the world in the research and development of life-saving drugs and technologies. And for this reason Rush may be correct in his implication that many (all?) foreigners would prefer to come here if they had a medical emergency. But having the newest medical technologies is not the same as delivering affordable health care equitably to a nation's citizenry. Many would say that the latter is at least as important as the former when it comes to appraising a nation's health-care system, and that the US has serious shortcomings by this measure.

It is possible that Rush, in the above passage, intends his conclusion that US health care is the best to imply that no significant reforms are necessary. There are two reasons to think that this might be so. The first is that nowhere in his five-page discussion of health care does he suggest that anything is wrong, or that anything needs to be done except to oppose the drift away from the free market toward government control. There is, he says on page 152, "no health-care crisis in this country". Secondly, he says, in the sentence prior to the original quotation above, that "the situation is not nearly as critical as Ms. Rodham would lead us to believe." And although in the preceding paragraph he had given reasons why the alleged 'crisis' was bogus, he continues on in this new paragraph as though he is giving new reasons why the situation is not critical enough to warrant significant change. If this is what he is doing, then he has an additional ARGUMENT which uses the first CONCLUSION as a PREMISS from which to draw the further CONCLUSION that the US health-care system is fine and doesn't need reform. Here's how it looks:

(2)　US health care is the best.
↓US health care is fine and doesn't need reform.

We've already seen reasons to doubt the COGENCY of (1), and therefore the truth of its CONCLUSION (which is the PREMISS of (2)). But even if the PREMISS of (2) were true, its CONCLUSION would not follow because, quite generally, *something can be the best without being very good.* It's possible that all existing health-care systems are unsatisfactory and need reform, even the comparatively better ones. (It just might be that the foreign national health-care systems of which Rush is so critical, need more free markets and less government control, while our system needs less free enterprise and more governmental regulation.)

So, if Rush is intending to make ARGUMENT (2), he's got a NON SEQUITUR (see Chapter 2, page 24).

Rush Limbaugh: A Discriminating Person

Rush delights in word play and fancies himself to be something of a semantic savant (a person knowledgeable about words and their meanings, for you dittoheads without dictionaries). As Rush likes to remind us, 'words mean things.' Sometimes his semantic 'insights' are the result of verbal equivocation. Here's Rush railing against 'discrimination'.

> Let's discuss that bane of modern liberalism, discrimination. Frankly, I'm getting tired of the word—at least the way it is used most of the time today. The fact of the matter is that I've been discriminating a lot lately. Sometimes discrimination is a good thing.
>
> For instance, I've been searching for a new place to live. . . . I have loved some and I have found others to be lacking. In other words, I have discriminated. . . . Therefore, discrimination is not always bad, is it? . . . [But] liberals have . . . the idea that discriminating among people, places, and things for any reason is wrong.
>
> (*See, I Told You So*, pp. 278–79)

In this passage, Rush argues that sometimes discrimination is a good thing, and he implies that liberals, who allegedly believe that all discrimination is wrong, are wrong. Here we have a complex of two ARGUMENTS with an implied second CONCLUSION. We may represent the complex as follows:

172

(1) Sometimes discrimination is appropriate (as in Rush's apartment hunting).
↓ **Sometimes discrimination is a good thing.**
But liberals think that discrimination is always wrong.
↓ **Liberals are wrong, silly, etc. (Implied)**

In (1), the CONCLUSION of the first ARGUMENT becomes a PREMISS of the second ARGUMENT; and that PREMISS together with the PREMISS that liberals think that discrimination is always wrong are PREMISSES for the second CONCLUSION, that liberals are wrong.

But in the second ARGUMENT, Rush seems to be confusing two distinct senses of the word 'discrimination'. In one sense it means simply to make a distinction among things of differing quality. This is generally a good thing. In another sense it means to treat a person unequally without good reason, based on some irrelevant feature of that person, such as skin color or religious affiliation. Discrimination in this sense, the sense in which liberals think discrimination is wrong, is never a good thing (or so liberals contend). The error here seems to be an instance of the FALLACY OF EQUIVOCATION, the FALLACY of using a word or phrase in two different senses in the ARGUMENT (see Chapter 2, page 34). We can show this clearly if we replace the equivocal term 'discrimination' with its appropriate meaning in each PREMISS of the second ARGUMENT.

(2) Sometimes *to make a distinction among things of differing quality* is a good thing.
But liberals think that *treating a person unequally without good reason* is always wrong.
↓ **Liberals are wrong**

It's pretty easy to see that in (2), with these different senses of 'discrimination', the CONCLUSION does not follow.

Of course, Rush might insist that he is not confusing two distinct senses of the word. He might say that, on the contrary, he is fully aware that the word has more than one meaning, and in one of those meanings discrimination is a good thing. But the liberals wrongly think that the word has only one meaning, according to which discrimina-

tion is always wrong. This defense of his reasoning—unusually subtle for Rush—may be represented as:

(3) Sometimes 'discrimination' means something which is a good thing.
But liberals think that 'discrimination' always and only means something which is wrong.
↓ Liberals are wrong.

Here there is no EQUIVOCATION. But if this is Rush's argument, then it suffers from the QUESTIONABLE PREMISS FALLACY; the second PREMISS is almost certainly false. Liberals do *not* generally believe that the word 'discrimination' always and only means something which is wrong, namely the unequal treatment of a person without good reason. Even liberals can read a dictionary, and even liberals would agree that some meanings of 'discrimination' allow the sort of discrimination (like distinguishing among apartments of differing quality) which is a good thing.

This form of QUESTIONABLE PREMISS is also a STRAW MAN, the FALLACY of mischaracterizing the opponents' position in order to make that position easier to refute (see Chapter 2, page 38).

Public Education?
A (nother) Complex Question

Here's Rush, plying a little Limbaugh logical legerdemain to expose yet another of the liberal deceptions—in this case about that relatively useless entity (thing, for you dittoheads with an aversion to metaphysics), *public education*.

In the course of proclaiming that the American government has undermined the true conservative values of the Founding Fathers, Rush says:

> Why were people better educated before the American Revolution with no public funding than in 1993, when we are spending in excess of $100,000 per classroom?
>
> (*See, I Told You So*, p. 76)

In this passage Rush is implying, though not explicitly stating, that our educational system is not working well and needs to return to some of the values and methods of pre-Revolutionary America. The reasoning looks like this:

(1) **People were better educated before the American Revolution than they are today, despite the expenditure of more than $100,000 per class room.**
↓ **Public education today is not working well and needs to be more like that of pre-Revolutionary America.**

There are several problems with this reasoning. But the most obvious is the use that the original passage makes of a deceptive device known as the COMPLEX QUESTION. Much like the lawyer's query 'When did you stop beating your wife?' Rush's question ('Why were people . . . ?') disguises two simpler questions: 'Were people before the Ameri-

175

can Revolution better educated than they are today?' and, if so, 'What is the explanation of that fact?' Obviously, unless the answer to the first question is 'yes', the second question does not even arise.

Rush offers little evidence that the answer to the first question is 'yes' other than a brief quotation in the preceding paragraph from the French historian, Alexis de Tocqueville. According to him, "In New England every citizen receives the elementary notion of human knowledge, . . . religion, the history of his country and the leading features of its constitution." Unfortunately, Rush seems not to have noticed that Tocqueville was describing *post*-Revolutionary America (around 1835) and may well have been describing, in large part, the effects of public education.

There are some good reasons for doubting Rush's unsupported claim that pre-Revolutionary Americans were better educated than Americans today. The nature of education—much of it sectarian, some of it the private, home variety—makes it very difficult to know with any confidence just who received education and how much they received. Even if all children got four or five years of elementary school and learned to read their Bibles, only a small percentage of males were prepared for college, while no females were. Virtually no slaves (roughly 20 percent of the population at the time of the American Revolution) received formal education, and virtually none could read.

Rush's COMPLEX QUESTION, it seems, contains a dubious assumption and, therefore, makes his ARGUMENT an instance of the FALLACY OF QUESTIONABLE PREMISS.

Index

Note: Page numbers in **bold face** show where a concept is first defined or explained.